IMAGES
of America

WEST BATON
ROUGE PARISH

IMAGES
of America

WEST BATON ROUGE PARISH

West Baton Rouge Historical Association

ARCADIA
PUBLISHING

Published by Arcadia Publishing
Charleston, South Carolina

Printed in the United States of America

Library of Congress Control Number: 2021940520

For all general information, please contact Arcadia Publishing:
Telephone 843-853-2070
Fax 843-853-0044
E-mail sales@arcadiapublishing.com
For customer service and orders:
Toll-Free 1-888-313-2665

Visit us on the Internet at www.arcadiapublishing.com

CONTENTS

Acknowledgments

The West Baton Rouge Historical Association wishes to thank executive director Dr. Angélique Bergeron and the staff of the West Baton Rouge Museum for their work on this project. In particular, we would like to recognize Lauren Hawthorne, West Baton Rouge Museum curator of collections and registrar Destiny Burnett for their contributions to *West Baton Rouge Parish.* Their dedication was invaluable and is deeply appreciated. We would also like to extend our appreciation to Joanne Bourgeois for her timely assistance in identifying and providing additional information for many of our Brusly photographs. And finally, a huge thank you to the West Baton Rouge Historical Association Book Committee for their service and support in the compilation and editing of the book. The committee members are Tom Acosta, Mary Bennett, Glen Daigle, and Brian Falcon. *Merci mille fois*!

Unless otherwise noted, all images appear courtesy of the West Baton Rouge Historical Association.

INTRODUCTION

West Baton Rouge Parish has been truly blessed by nature—bounded by the waters of the Mississippi River to the east and the Atchafalaya Basin to the west and crisscrossed by major rail lines, interstate, federal and state highways, and the Intracoastal Waterway. Our location across the Mississippi River from Louisiana's state capital, landmark universities, and industries on the convergence of waterways, train routes, and scenic highways has brought together a rich and diverse population of people and cultures on this land.

This book contains images collected by the West Baton Rouge Historical Association over our 50-plus years of historical preservation. Founded in 1968, the West Baton Rouge Historical Association preserves and promotes the rich history of our little corner of Louisiana. A huge debt of gratitude is owed to the founders of the West Baton Rouge Historical Association, who were inspired by the vision that local history was important and worthy of preservation—even (and especially) in small rural communities such as ours.

Local history is important to those of us who live here. It is also worth knowing and cherishing as it truly serves as a microcosm of state, national, and world history. The West Baton Rouge Parish connections to state, national, and international stories are broad, deep, and often surprising—even to those who have resided in the area their entire lives. The water that flows through the canals, lakes, rivers, bayous, and streams in this region and connects us to the waters of the world is a metaphor for the trickle of humanity connecting and influencing West Baton Rouge Parish people, places, and events through the ripple effect of people, places, and events taking place in Louisiana, the United States of America, and the world.

Our history teaches us about our community and its growth—reminding us that history happens all around us every day. Understanding where we came from and how we got to where we are today empowers our citizens, giving them pride in our accomplishments and an appreciation for the hard work and sacrifices of those who came before us. It is important for all citizens—but especially for our youth—to know and understand local history. Younger residents will soon be writing the next chapters of West Baton Rouge history themselves, and their navigation and ambitions will determine the future of this place we call home.

West Baton Rouge Parish explores the pictorial past of our parish through the lens of images housed in the West Baton Rouge Historical Association's permanent collection. These images, donated by locals, have been categorized by the following topical themes: transportation, government and political figures, commerce, plantations and agriculture, churches and schools, and community. We sincerely hope that this publication will prove nostalgic for some older readers, provide discovery for younger generations, and inspire inquiry in many others wishing to research our history beyond the photographs on these pages.

Significant transportation innovations over the past 200 years have played an important role in the development of West Baton Rouge Parish. Towns sprouted up along railroad lines; the rapidly growing popularity of automobiles led to the gradual paving over of dirt and gravel roads;

and wagon, rail, and motor vehicle ferry boat service yielded to the vast expansion of rail and road traffic resulting from the mid-20th century construction of the two bridges spanning the mighty Mississippi River. These bridges not only linked our small parish to our neighbors and state capital to the east, but they also facilitated commerce between the eastern/western parts of the United States. Looking back to where it all began, we can reflect on the not-so-distant past with images of horse-drawn carriages, the old ferry landing, and once earthen streets that are now surfaced in cement.

Portraits and candid captured moments of government and political figures give a face to oft-forgotten names found on local streets, a bridge, and even a parish town. Pictures in this section include the first woman to hold political office in West Baton Rouge Parish, in addition to those of state legislators and Louisiana's 1904 governor. First responders from the past, including a physician and members of fire and police departments, are recalled as well.

Commerce developed around settlements, and as communities evolved, so did the need to provide necessities for the people who lived here and for the sale of the fruits of their labor. Selected photographs follow the establishment of early businesses, local proprietors, and the various ways products were shipped. Items were bought and sold at general stores and drugstores. Fuel was pumped at early gas stations. Banks were established, grew, moved, and sometimes failed. Business was conducted in a thriving downtown Port Allen. The 1960 construction of the Port Allen Lock opened a vital shortcut between the Mississippi River and the Gulf Intracoastal Waterway for barges carrying goods throughout the world and led to the expansion of the Port of Greater Baton Rouge.

The rural landscape of West Baton Rouge Parish is still dotted with the remnants of bygone plantations. From stately houses to sugarhouses, some of these structures still stand, while others now replaced by industry exist only in photographic images. Sugarcane—the area's chief cash crop—as well as the labor-intensive process of turning cane into sugar crystals are depicted, together with unidentified field/mill workers, farmers and families, and landmarks, including smokestacks and architectural details of 19th- and early-20th-century dwellings.

Churches and schools form the heart of any community, along with their associated customs and traditions. These images include Protestant and Catholic places of worship, baptisms, schoolhouses, team and club photographs, graduation, and classroom activities.

Community is more than just a place, it is a sense of belonging and of pride in one's home, a bond that links its members in good times and in bad. Pictured here are celebrations, catastrophic events, assorted artifacts displayed in the early days of the West Baton Rouge Museum, a natural landmark, and a work of public art.

The West Baton Rouge Historical Association's permanent collection is housed at the West Baton Rouge Museum, a publicly funded regional history museum set on a tree-covered six-acre campus in the parish seat of Port Allen. The permanent collection contains over 8,000 objects, 3,000 photographs, and a growing historical archive of significance to the parish and the surrounding area. The pages that follow provide a glimpse into this collection and will take readers on a visual journey through time, noting the evolution, presence, and absence of people, places, and landmarks along the way. We hope you enjoy perusing these images as much as we relish sharing them with you!

One

TRANSPORTATION

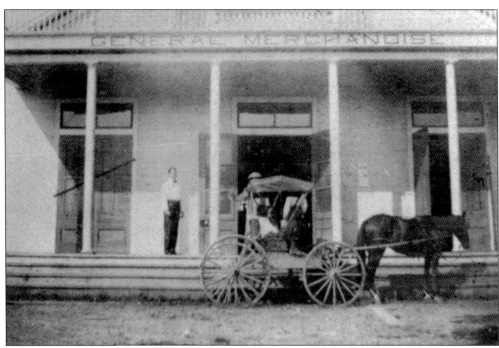

This c. 1900 photograph shows a horse-drawn carriage in front of Levert Brothers General Store at St. Delphine Plantation. An unidentified man is at the reins of the carriage, and two unidentified men are on the porch. It is speculated that the man on the porch in the white shirt is Delma Landry. He would have been the store manager at the time.

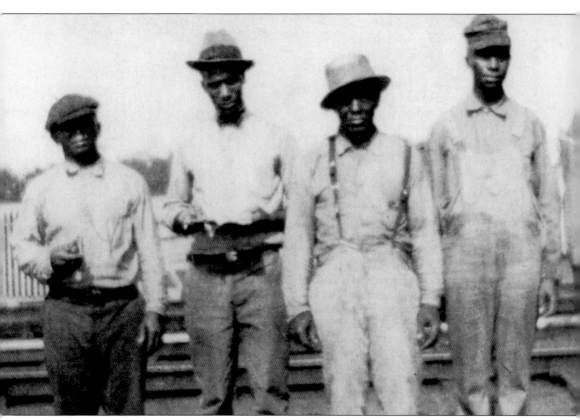

This is an early-20th-century image of a crew of four switchmen for the railroad ferry boat, the *George H. Walker* at Anchorage. Alfred James Washington is the man on the far left. The three other men are unidentified.

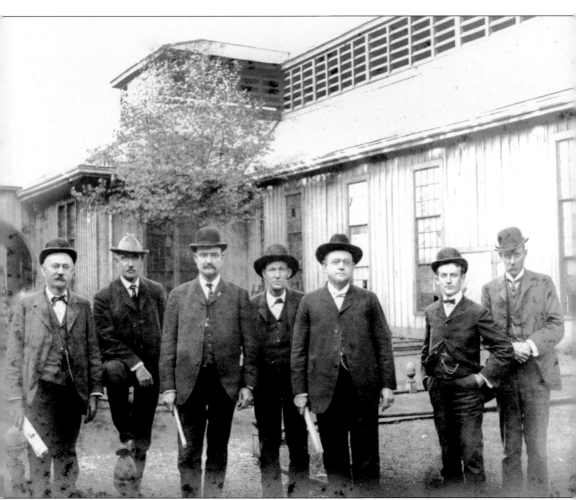

This photograph, taken in 1904, shows officials from the Texas & Pacific Railroad in front of one of their buildings. From left to right are W.D. Milton, J.B. Paul, John Wesley Addis (the town of Addis is named in his honor), C.W. Campbell, and L.S. Thorne. Milton was a master car builder, Paul was superintendent of motive power and rolling stock (today the title would be mechanical superintendent), Campbell was superintendent of Eastern Division, and Thorn was vice president and general manager.

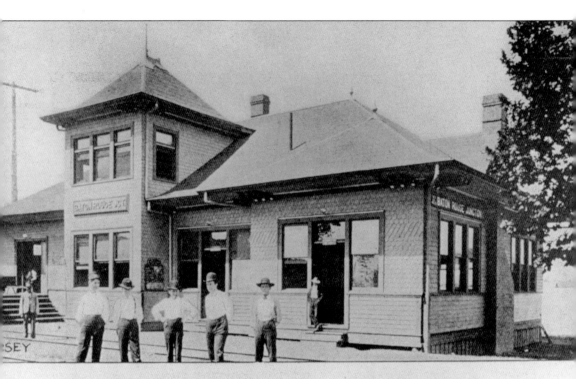

THE NEW T. & P. PASSENGER STATION, BATON ROUGE JCT., LA.

This 1908 photograph features eight unidentified men standing in front of the Texas & Pacific Railroad Depot in Addis. The station was originally known as Baton Rouge Junction. It changed to Addis sometime between 1908 and 1910. Through the years, Texas & Pacific was absorbed by Missouri Pacific Railroad and then eventually merged with Union Pacific Railroad.

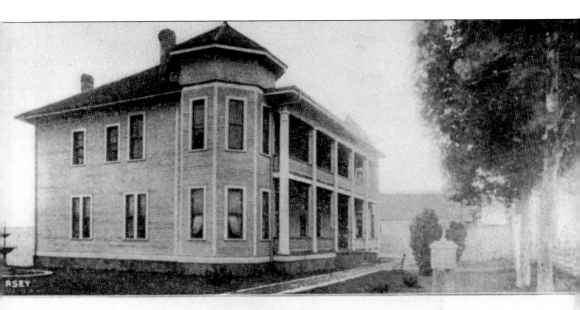

NEW TEXAS & PACIFIC EATING HOUSE, BATON ROUGE JCT., LA.

This photograph from the early 20th century depicts the Texas & Pacific Railroad eating house in Addis. It was built in 1904 and provided beds and meals to the myriad of passengers and railroad employees.

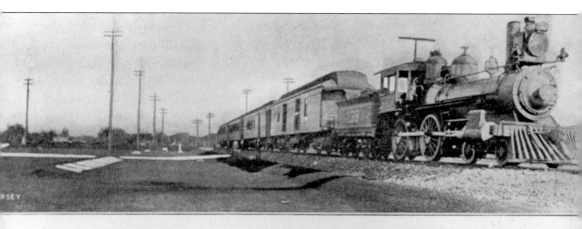

A SAMPLE OF TEXAS & PACIFIC RY. NEWLY BALLASTED TRACK ON LOUISIANA DIVISION

Texas & Pacific Railroad operated two passenger trains that rolled through the station at Baton Rouge Junction: *Night Express* and the *Louisiana Limited*. Above is a 1905 picture of one of the trains as it came through.

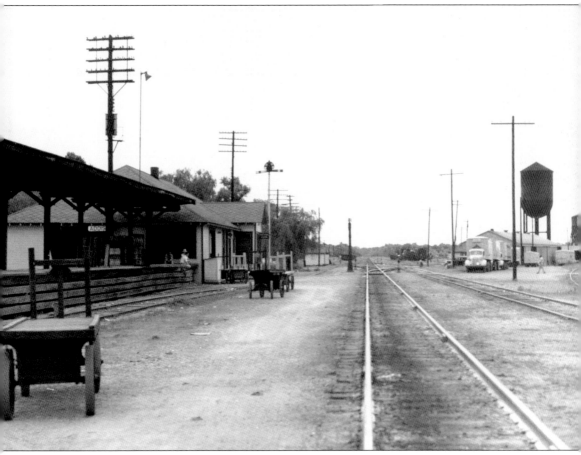

The railroad depot in Addis is pictured here in the late 1940s. The railroad has long been a part of connecting West Baton Rouge Parish to larger outlets across the country. Today, there are two major railroads that run through West Baton Rouge: Kansas City Southern Railroad and the Union Pacific Railroad. They use railroad yards in Addis, Port Allen, and Anchorage.

Before the Huey P. Long-O.K. Allen railroad bridge was opened in 1940, trains crossed the Mississippi River by ferry near Anchorage, just north of Port Allen. This photograph shows the train ferry, the *George H. Walker*, which was used by the Missouri Pacific Railroad. An engine on

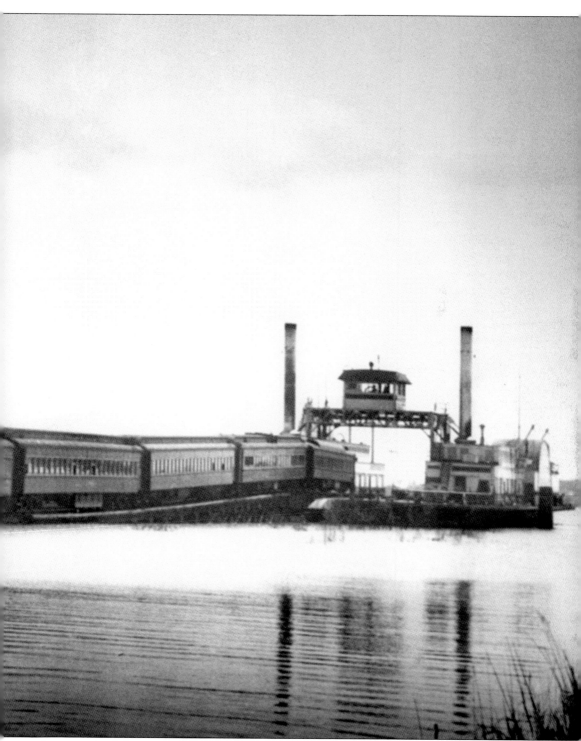

the west side of the river put the train on the ferry, and an engine on the east side took the train off the ferry. This allowed trains to continue traveling on to New Orleans and other destinations.

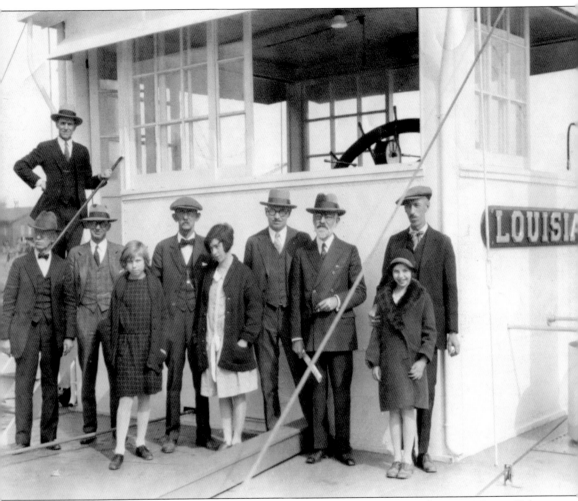

Standing on the deck behind the pilothouse of the ferry *Louisiana* around 1926 is Marion Kahn (second from the left), the ferry chief engineer; William Gibbons (fourth from the left); and Capt. James E. Howard and his daughter Martha (at the far right) with other unidentified patrons. The ferry company purchased the *Louisiana* in 1926. It had a capacity of 1,000 people and could also hold 60–70 cars.

In 1916, the Baton Rouge Transportation Company garnered a contract to operate a ferry system running between Port Allen and Baton Rouge. Although the operation changed hands, the ferry system was quite successful and ran until 1968. The picture above is a ferry approaching on the Westside at the foot of Court Street in Port Allen in 1927.

This is an image of the ramp up the levee on Court Street looking west. It features the early days of Port Allen when the streets were meandering and unpaved. A good number of people can be seen in the background walking around while a single car drives down the road.

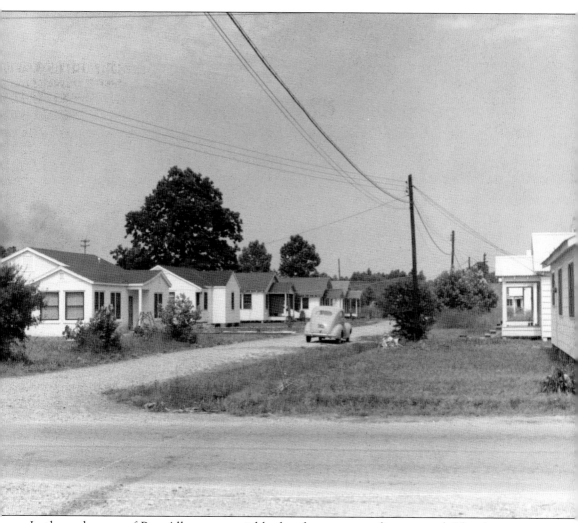

In the early years of Port Allen, most neighborhood streets were dirt or gravel. They became muddy in the cooler, rainy months and dusty in the warmer summer months. The effort to pave these streets did not begin until the late 1950s. Pictured above is a view of the intersection of North Jefferson and Georgia Avenues in Port Allen from the 1940s. The three houses on the left are still standing, although they have been somewhat modified over the years.

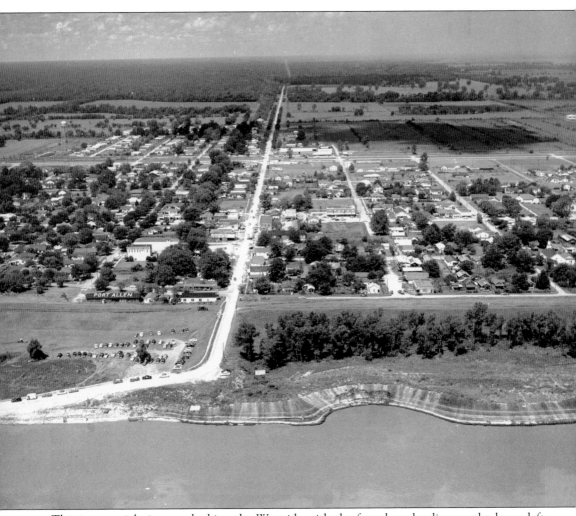

This is an aerial view overlooking the Westside with the ferry boat landing on the lower left side. Cars would drive down Court Street, line up at the levee, and wait for the ferry to return. There was an area to park automobiles or one could drive directly onto the ferry to cross the Mississippi River.

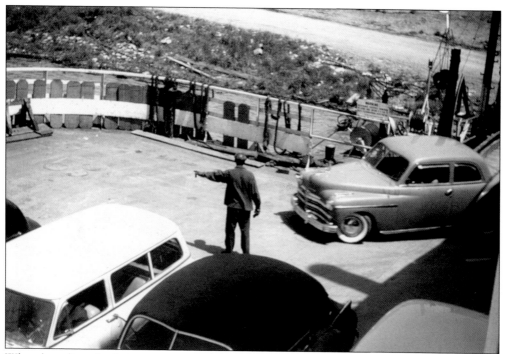

When boarding the ferry in an automobile, a dock attendant would direct people on and show them where to park their vehicles for the trip across the river. After the car was parked on the vessel and the ferry was moving, people were free to get out and stand on the deck and look out over the railing.

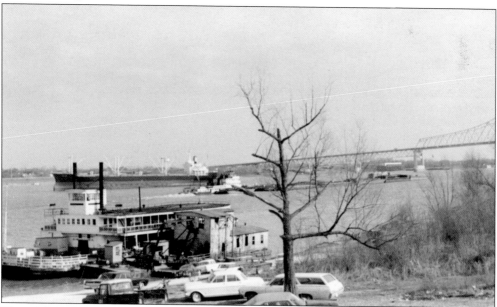

This 1968 image shows the ferry boat *Louisiana* docked at the ferry landing in Port Allen. The new Mississippi River bridge can be seen in the background. The bridge opened in April of that year. The ferry continued to run for a few months after the bridge opened but later stopped operation due to low traffic.

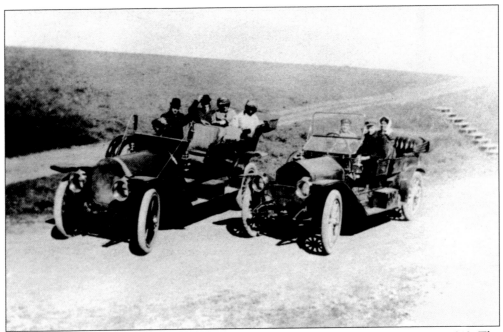

There was a huge surge in the automobile industry during the period from 1910 to 1919. The decade saw an increase in car production, which led to many more cars on the streets. This picture, taken around 1910, with the inscription "On the way to plantation" is from a Martin Kahao family photo album.

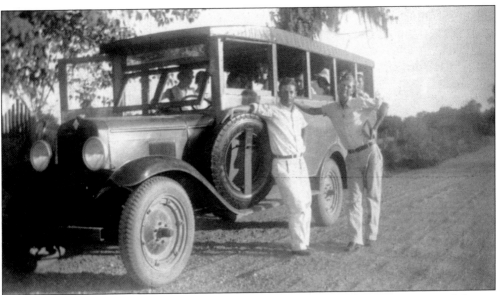

The 1930s ushered in the Great Depression in the United States. Owning an automobile was not the norm that it is today. Many people took the bus for transportation. It was during the 1930s that buses saw advances in their design and production. Some of these improvements are still in use today. The image above, taken in the 1930s, is of the first glass-windowed bus in West Baton Rouge.

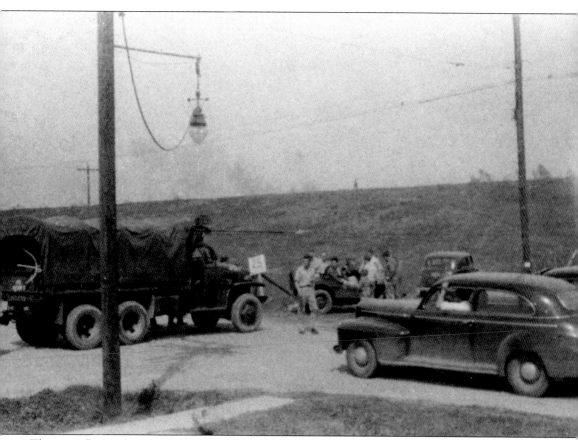

There is a flurry of activity on River Road as workers arrive in trucks and cars to assess and begin repair on the levee after the flood of 1949.

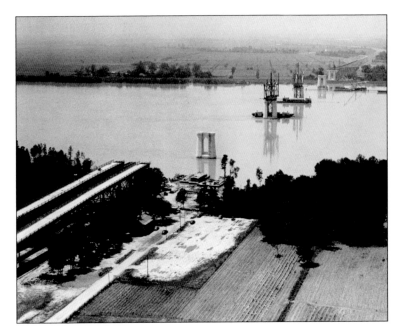

The ferry system was essential for getting people across the Mississippi River for decades, but as automobiles became a more common mode of transportation, the need for a bridge to cross the river became evident. So in 1937, construction began, and the bridge opened to trains and vehicles in August 1940. This is an image of the construction.

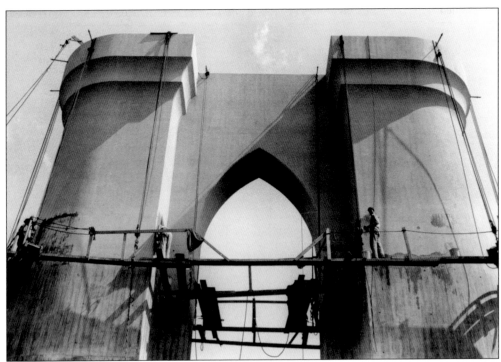

Two men can be seen on the scaffolding surrounding one of the piers of the Mississippi River bridge. The construction of the Huey P. Long–O.K. Allen Bridge proved to be precarious work. Nine workmen lost their lives during the construction.

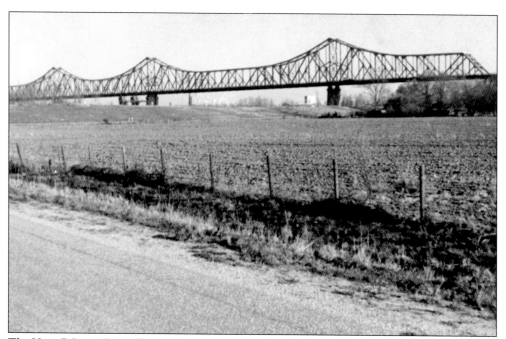

The Huey P. Long-O.K. Allen Bridge is a truss cantilever bridge that connects Port Allen to Baton Rouge on the north side of the parish. Locals commonly refer to it as the "Old Bridge." It was the only bridge in the area across the Mississippi River until 1968, when the Horace Wilkinson Bridge was opened. This particular view is taken from River Road north of the bridge at Mulatto Bend.

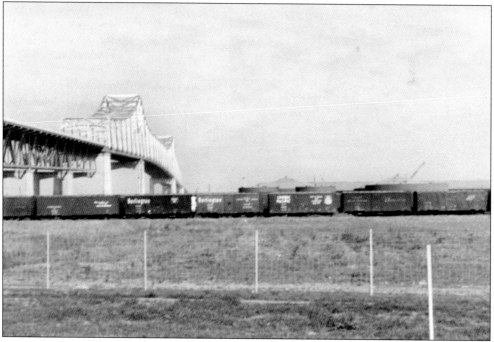

A new bridge was constructed and opened in 1968. It was part of the plan for Interstate 10 and connected Port Allen to downtown Baton Rouge. It was named the Horace Wilkinson Bridge, but it is often referred to by locals as the "New Bridge."

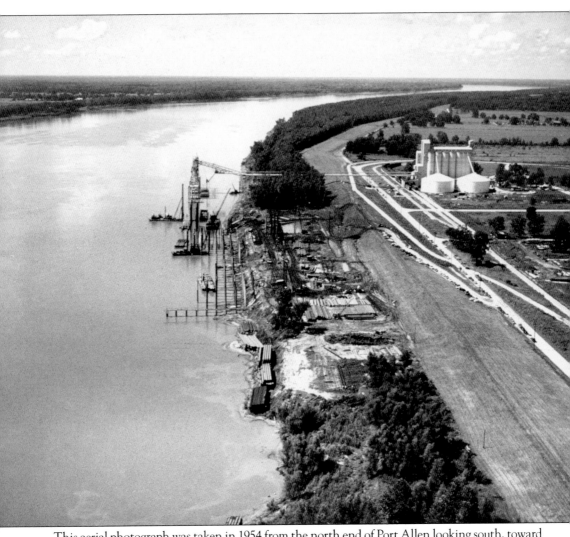

This aerial photograph was taken in 1954 from the north end of Port Allen looking south, toward the Port of Greater Baton Rouge, while the bridge was still under construction. It illustrates the advanced growth Port Allen was making at that time. During the next year, work would begin on the Port Allen Lock.

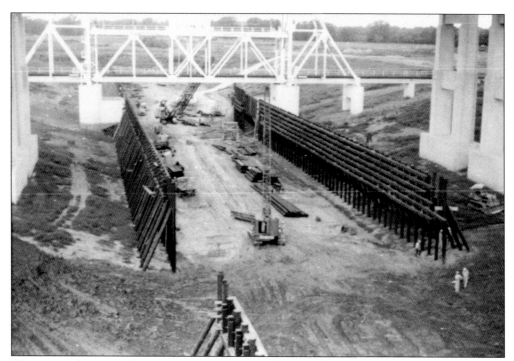

This image shows the digging and construction of what will become the Port Allen Lock. The lock connects the Mississippi River to the Gulf Intracoastal Waterway, shortening the distance to the Gulf of Mexico.

The lock's walls are still under construction in this picture. Construction began in 1961. When finished, it made West Baton Rouge Parish the hub of the Gulf Intracoastal Waterway where it intersects with the Mississippi River.

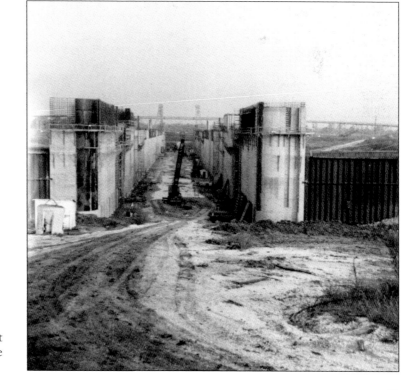

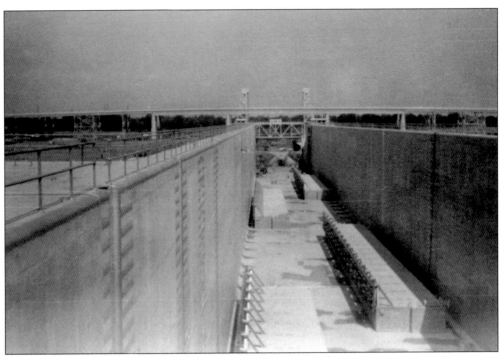

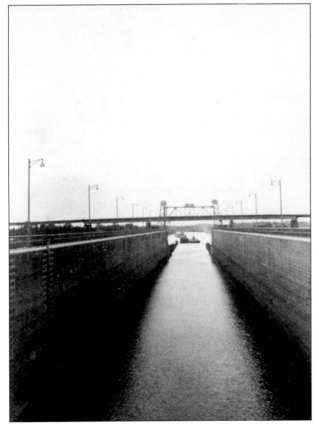

Construction is in progress in this photograph of the Port Allen Lock. Once completed, the water from the Mississippi River would flow through to the Gulf Intracoastal Waterway.

The finished Port Allen Lock with water moving through it to the Gulf Intracoastal Waterway. The waterway is designed primarily for the transportation of barges. It sustains a channel with a depth of 12 feet. This is an image of the waterway with barges at one end.

Two

GOVERNMENT AND
POLITICAL FIGURES

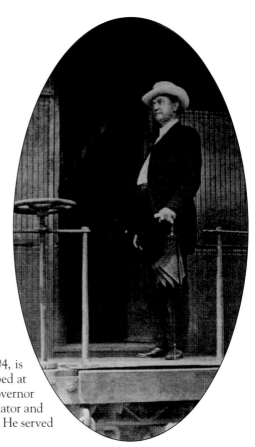

Gov. Newton Blanchard, pictured around 1904, is
standing in the doorway of a railroad car stopped at
Baton Rouge Junction, which is now Addis. Governor
Blanchard was a US representative and US senator and
became the 33rd governor of Louisiana in 1904. He served
for one term.

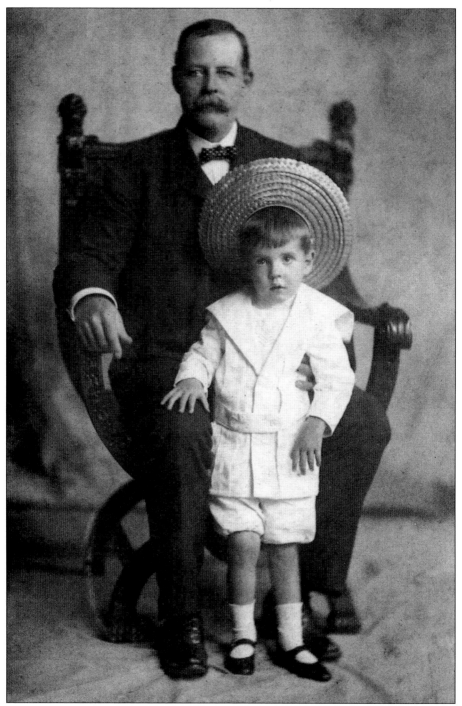

Horace Wilkinson is pictured here with his son Horace Wilkinson Jr. around 1890. Horace Wilkinson was born in 1854 and was a prominent sugar planter in West Baton Rouge. He served in the Louisiana State Legislature for 26 years. Horace Wilkinson Jr. followed in his father's footsteps as a sugar planter in West Baton Rouge, and he also served in the state legislature for 16 years. (Courtesy of Ann Wilkinson.)

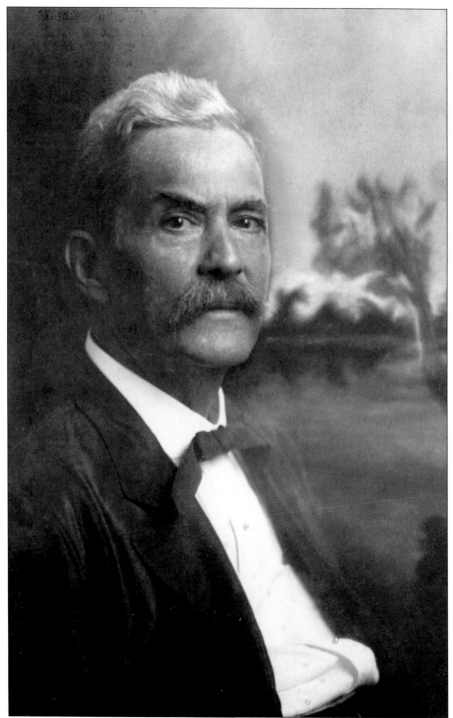

This portrait of David Devall was taken in August 1912 when he was elected to represent West Baton Rouge Parish to the Louisiana State Legislature at the age of 70. From Orange Grove Plantation, Devall also served as president of the West Baton Rouge Police Jury, the governing body of the parish, in 1903.

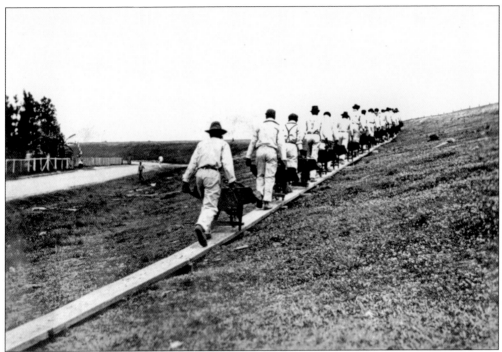

These photographs from May 1922 show workers moving wheelbarrows up and down the levee during the construction of the levee support system because of imminent high water in West Baton Rouge. Levees were first constructed in Louisiana in the 1720s to protect New Orleans from floods. Plantation owners were required to construct their own portion of the levee if located along the river. There have been many floods and crevasses that have appeared in West Baton Rouge Parish's levee system through the years, with the last occurring during the 1949 flood.

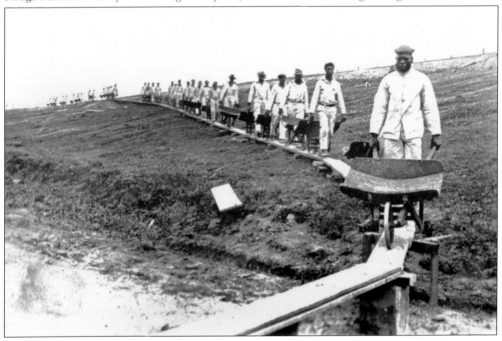

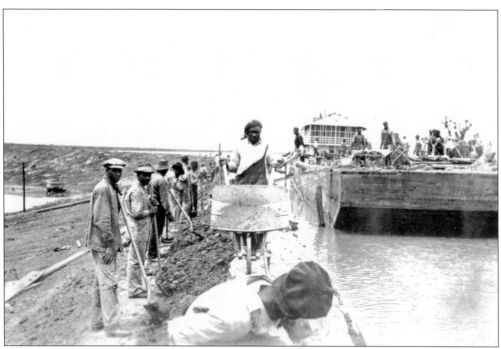

Many men were needed to fortify the levees. These two photographs show workers with shovels and wheelbarrows piling dirt to build up support. Due to the costly ruin and devastation of floods, the US Congress passed the Flood Control Act of 1917. The terms of the act were designed to reduce damage caused by floods along the Ohio, Sacramento, and Mississippi Rivers. It authorized flood control work outside the Mississippi Valley and directed local communities to contribute half of the cost of the levee construction projects. It also required communities to maintain levees once construction was complete.

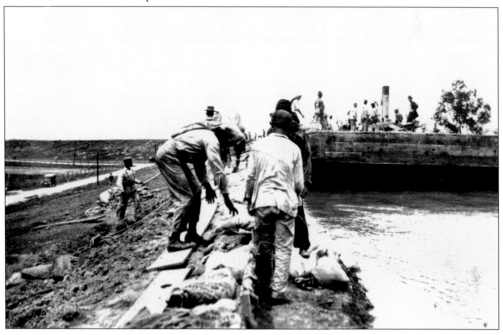

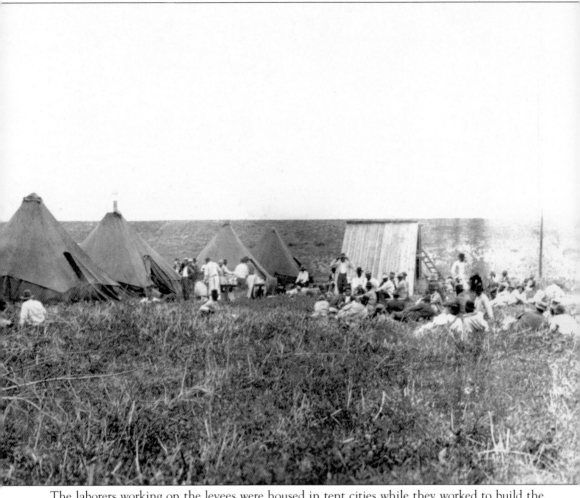

The laborers working on the levees were housed in tent cities while they worked to build the support system. They are seen here relaxing at mealtime following a hard day's work.

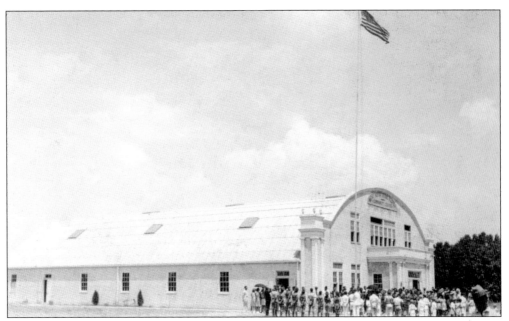

A large crowd is assembled in front of the Port Allen Community Center on North Jefferson Avenue for the dedication ceremony in 1937. Construction of the building began in 1936 as a Works Progress Administration project.

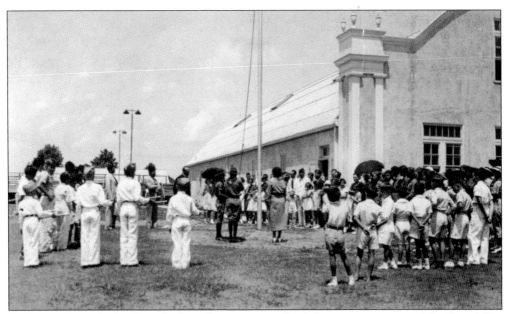

A group surrounds the flagpole for a flag raising at the dedication ceremony of the Port Allen Community Center. Over the years, the front facade was replaced with a more modern one.

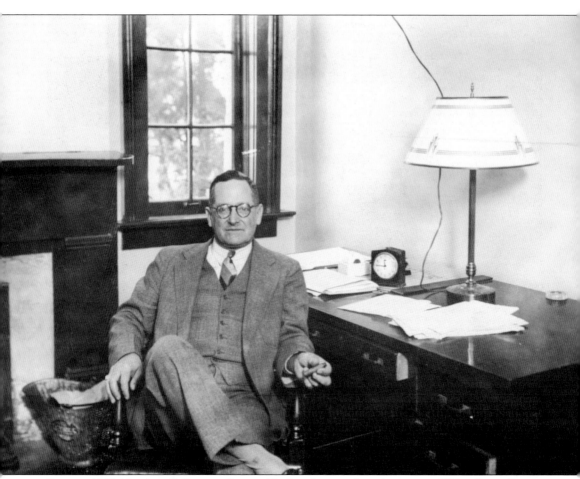

Born in 1888, Nemours F. Pecquet Sr. was 42 when he was elected assessor of West Baton Rouge Parish. He held that position for 26 years. Pecquet is seen here in his office in the late 1930s.

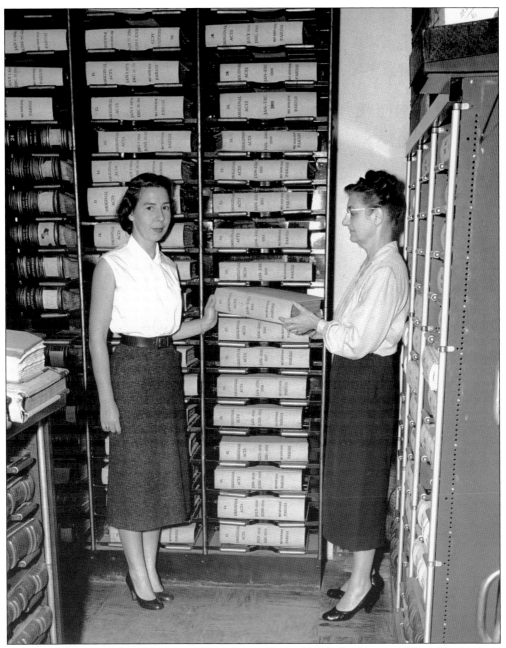

Victor Lefebvre was clerk of court in West Baton Rouge Parish for 24 years. Upon his death in 1940, his wife, Elsie Lefebvre, was appointed to fill his unexpired term. She became the first woman to hold a political office in the parish. When the term came to an end, she ran and was elected in her own right. Elsie Lefebvre (left) is pictured here in 1949 in the records vault of the third parish courthouse.

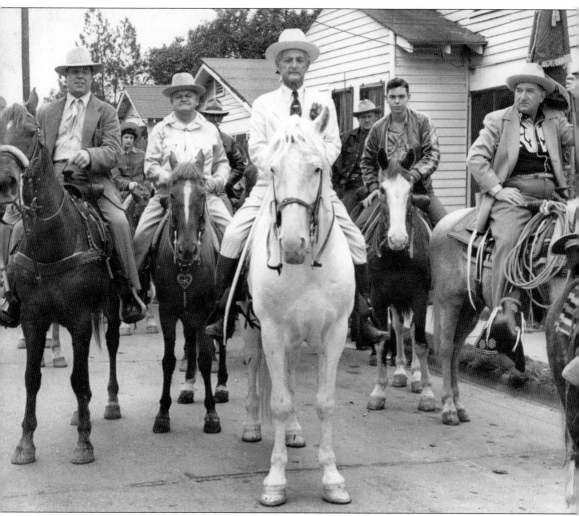

Ferdinand "Ferd" Claiborne sits on his white horse, King, during a 1952 rodeo parade. The other people pictured are unidentified. Claiborne started practicing law with his father, Louis B. Claiborne, in 1906. He later became a founder and president of First National Bank of Pointe Coupee. He was elected to three terms in the Louisiana State Legislature and also served as district attorney for West Baton Rouge Parish from 1929 to his death in 1959.

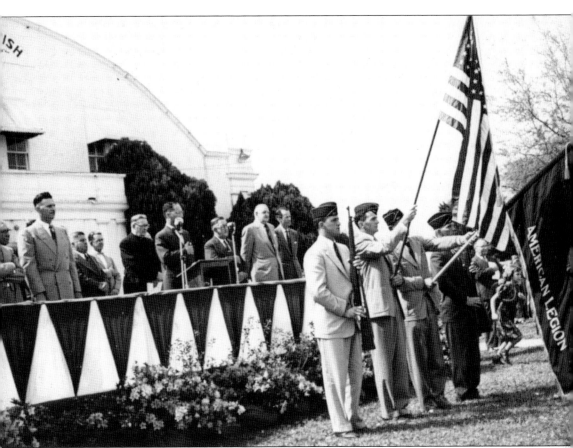

Pictured is a scene from the dedication ceremony of the new city hall in Port Allen on March 21, 1954. From left to right, local dignitaries Ralph Altazan, Father Domsdorf, Eugene Alexander, Charles Schnebelen, Stanley "Slim" Noble, and Clyde Fant look on from the platform as the colors are raised.

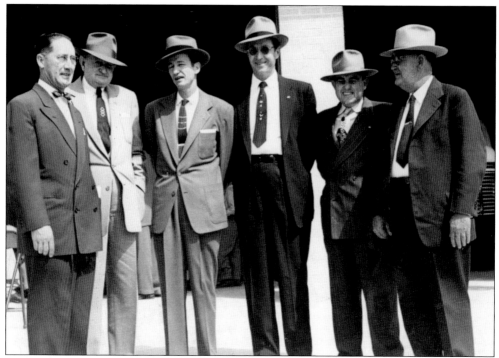

An assembly of mayors attended the Port Allen City Hall and Port Allen Fire Station dedications in 1954. From left to right are Port Allen mayor Eugene Alexander, Zachary mayor Stanley "Slim" Noble, Shreveport mayor Clyde Fant, R.O. McCranie, and two unidentified men.

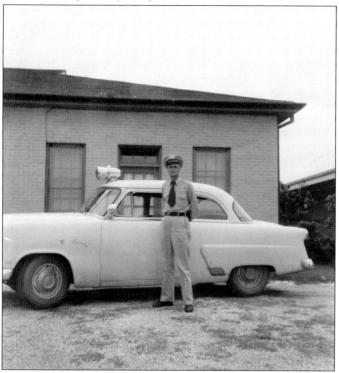

In this 1953 photograph, a Port Allen police officer solemnly stands in front of his police cruiser. This car is equipped with a rooftop flashing light and a siren. This particular vehicle is an unmarked unit. By the mid-20th century, American car manufacturers began mass producing specialized cars for police departments.

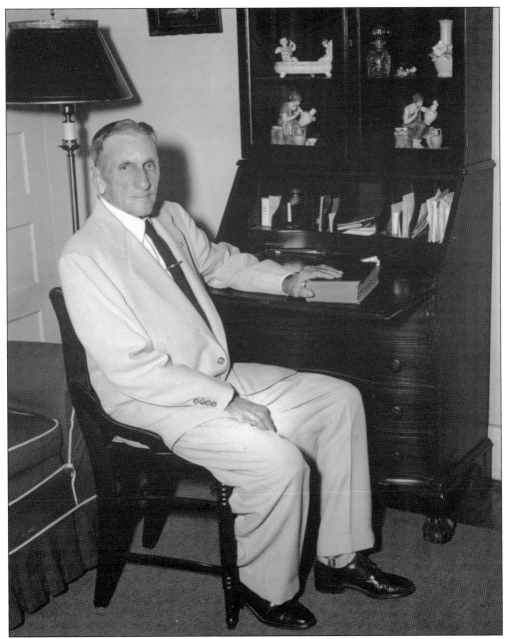

Dr. Paul B. Landry Sr. is pictured at his home in 1954. Dr. Landry was a Port Allen physician and surgeon. He was elected coroner of West Baton Rouge Parish in 1920 and reelected in 1924. He also served as mayor of Port Allen from 1918 to 1920. He is remembered fondly by many in West Baton Rouge Parish. One of his patients said of him, "He was a competent, considerate doctor, and a good diagnostician, also a very charitable man to all his patients, especially the poor ones."

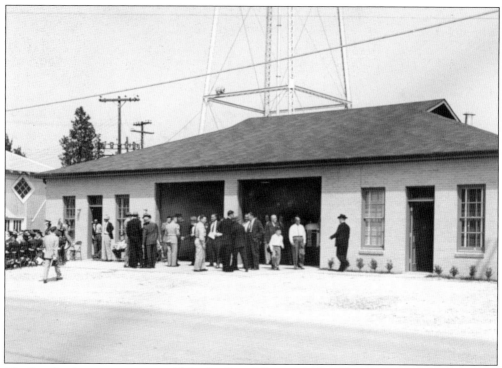

The first fire department was established in Port Allen in 1935. With only 15 volunteer members, the first company was formed. They had no motorized equipment and were basically a bucket brigade. After Henry Cohn Jr. passed away, his heirs donated land for a municipal building. It housed the first firehouse, the town clerk's office, the mayor's office, and a council room. This picture is from the dedication of that building in 1954.

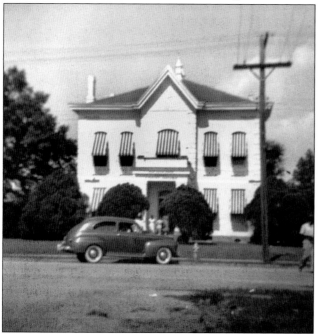

The third West Baton Rouge Courthouse building stood from 1882 to 1956. It had been designed by Henry Howard, one of Louisiana's most prolific architects at the time. The courthouse was demolished but an extension that was the records vault remained and became the first library in West Baton Rouge Parish. Later, that building became the West Baton Rouge Museum.

This photograph, dated on the back as June 8, 1954, shows Mayor Eugene Alexander and his wife, Vivian, at a Mayors and Police Jury Presidents dinner. Mayor Alexander was beloved by the residents of Port Allen during his 30-year tenure, and a section of Highway 1 was named North Alexander Avenue in his honor.

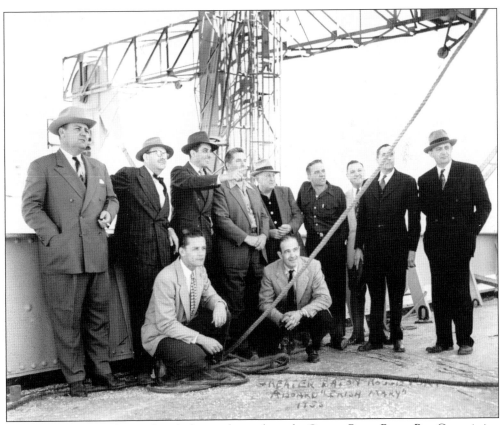

Pictured are a group of 11 unidentified men who made up the Greater Baton Rouge Port Commission standing aboard the *Irish Mary*. The Louisiana State Legislature established the Greater Baton Rouge Port Commission in 1952.

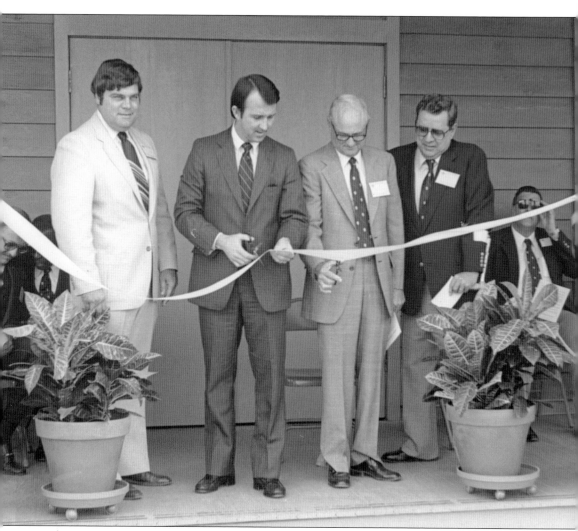

The West Baton Rouge Parish Tourist Center opened in October 1982. It served to provide information about local attractions and places to stay for visitors of the area. The men featured in the photograph are, from left to right, Jerry Guillot, Pat Screen (mayor of Baton Rouge from 1981 to 1988), Leo Blaize, and Tom Bernard.

Three

BUSINESS AND COMMERCE

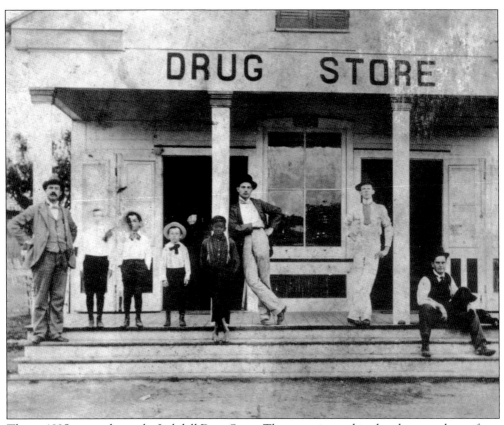

This c. 1895 image shows the Lobdell Drug Store. The men pictured in the photograph are, from left to right, Dr. Frank Carruth; his sons Frank, Hill, and George; Freddo Williams; Frederick Gatz; Charles McDonald, the store pharmacist; and an unidentified man with his dog.

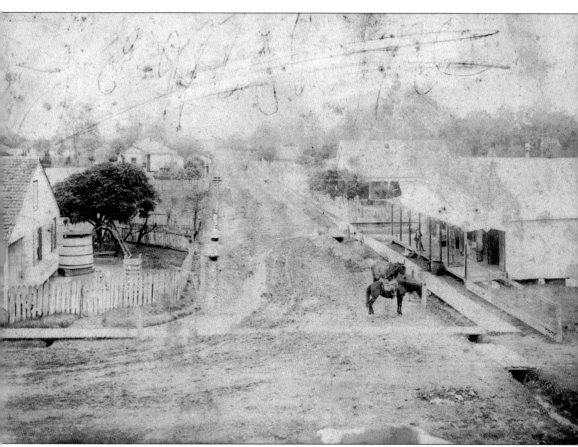

This photograph from March 14, 1908, shows downtown Brusly at the intersection of Bourgeois Street, when it was Labadiole Street, and the levee at the landing. The first Brusly Drugstore can be seen on the right with a horse and mule in front. It is believed that the first drugstore in America was established in New Orleans in 1823. It is said to be the first drugstore because it was the first to be opened and run by a registered pharmacist.

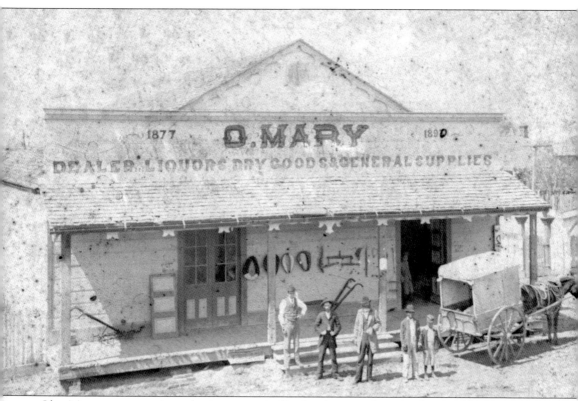

Olga Mary was a prominent business man in Brusly who served on the first board of directors of the Bank of West Baton Rouge when it was formed in 1905. He also served on the first West Baton Rouge Parish school board in 1900. This photograph of the O. Mary Store was taken in 1908. Louis Hebert's bread wagon can be seen at right.

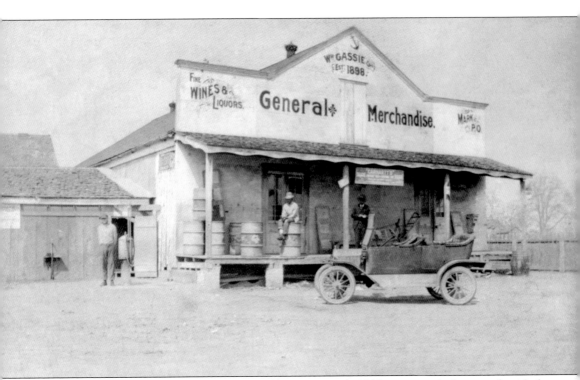

The William Gassie General Store is pictured here in an early-1900s image with three unidentified men standing out front. William Gassie Sr. operated the store, which also housed a post office. The store was a large two-story building with living quarters at the back end of the second story.

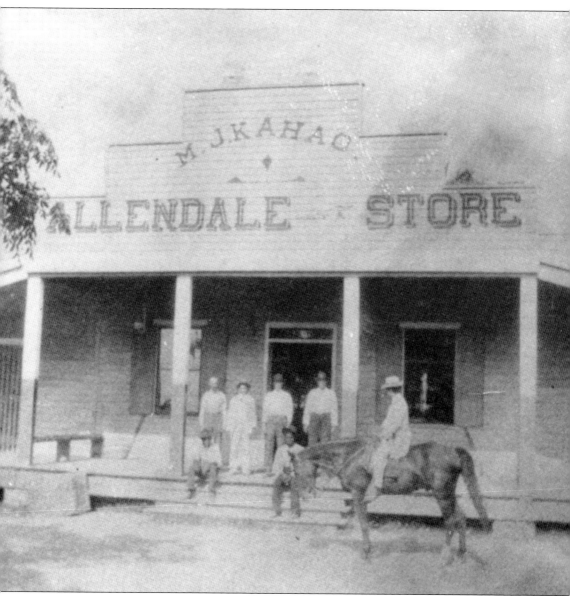

Martin J. Kahao, owner of Allendale Plantation, is shown on horseback in front of the M.J. Kahao Allendale Store. There are six unidentified men on the porch. The photograph was taken around 1910.

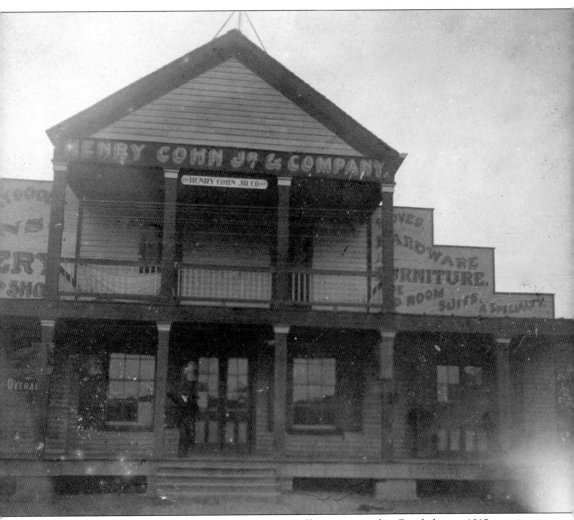

The Henry Cohn Jr. & Company store was originally constructed in Brusly but in 1912 was torn down and rebuilt in Port Allen. It was sold in 1941 and became Allie's Department Store. It was then sold again, in 1951, to L.E. Bourg and became Bourg's Drug Store, which is still in business as of this printing.

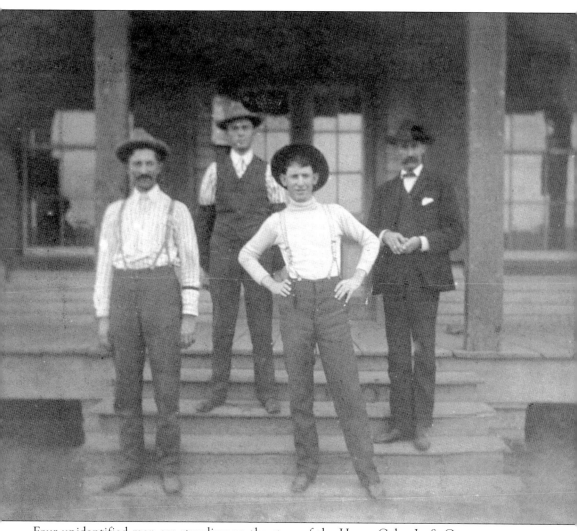

Four unidentified men are standing on the steps of the Henry Cohn Jr. & Company store around 1915.

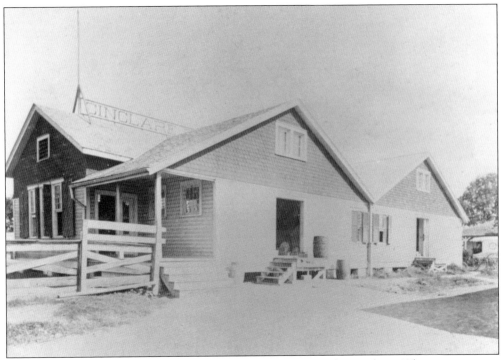

An early-20th-century view of the Cinclare Plantation Store is shown above. The store was part of the plantation complex on the grounds at Cinclare. It sold a wide variety of merchandise, food, and hardware.

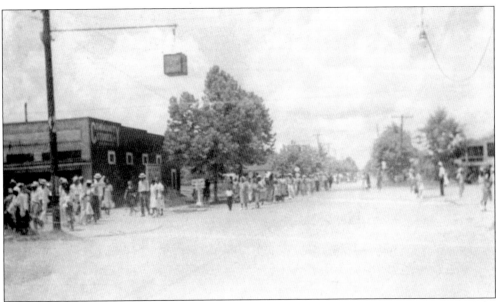

This image features a glimpse of downtown Port Allen in the early 20th century. Most of the buildings and shops were built close together, creating a section of town where everything anyone needed was in one convenient area. This made it easy for locals to walk from store to store.

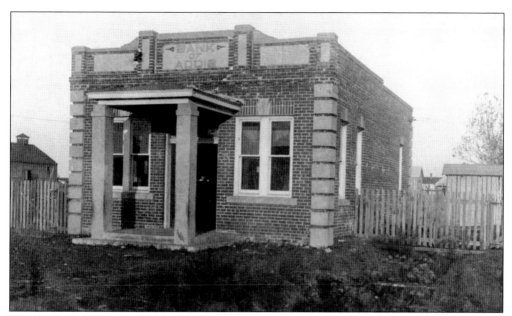

The Bank of Addis was chartered in December 1919. S.A. Levert was the bank's first president, with William Myhand as vice president and William Gassie Jr. as cashier. Business declined a few years after opening, and in 1925, the Bank of Addis merged with the newly opened Port Allen Bank & Trust Company.

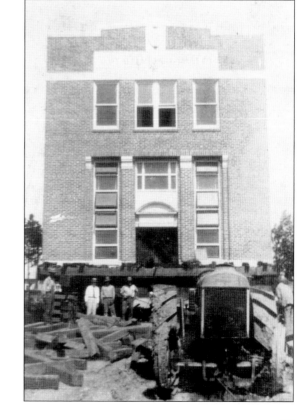

The Port Allen Bank & Trust Company, around 1925, was in the process of being relocated to accommodate the levee setback and provide additional land for the floodplain. The structure was a three-story brick building, which made moving it a very difficult feat. A tractor and five unidentified men stand in front of the building.

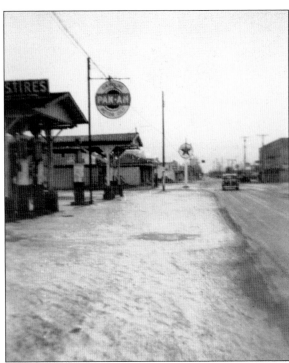

Pictured is a 1940s view of a Port Allen street with a Pan-American gas station and Texaco gas station in the background.

This look at Court Street in Port Allen from the 1940s is facing east toward the old ferry landing. At the time, Court Street was the principal commercial street in Port Allen.

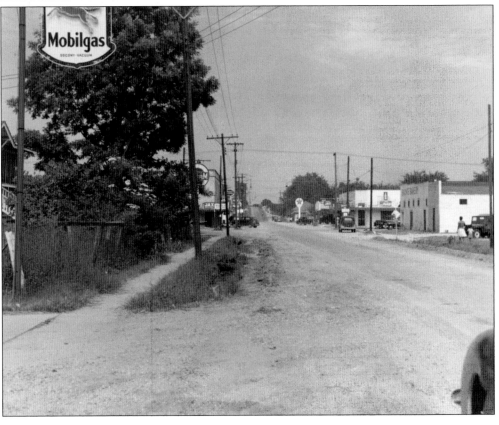

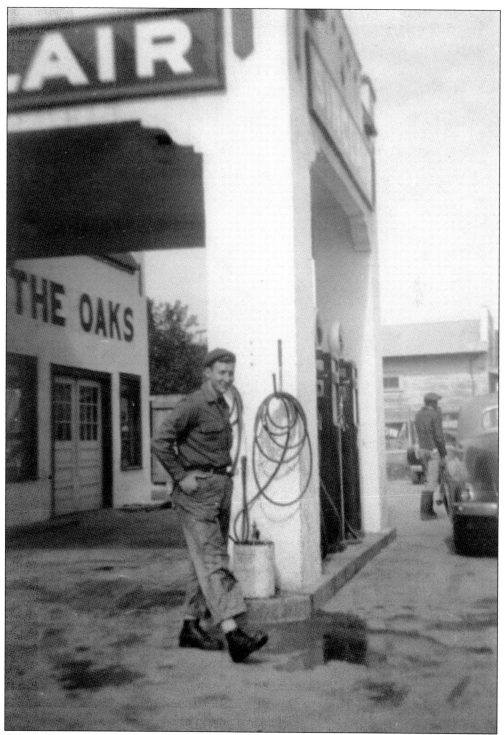

Sidney Pourciau poses at the Sinclair service station around 1945. Pourciau was an attendant at the station, which was located in the Oaks neighborhood of Port Allen. Bourg's Grocery Store can be seen in the background.

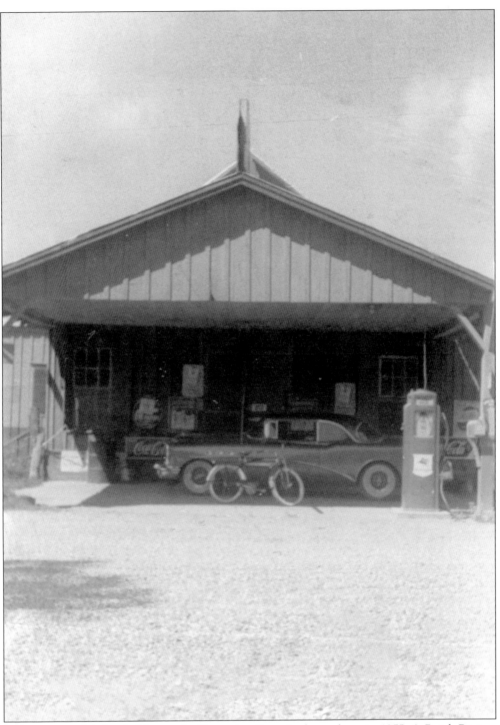

A front view of Arbroth Mercantile Plantation Store is shown here in 1955. A Buick Riviera Special is parked next to the filling tank. In 2009, the Arbroth store was moved from its original location on Arbroth Plantation in the north end of the parish. The store now rests on the grounds of the West Baton Rouge Museum.

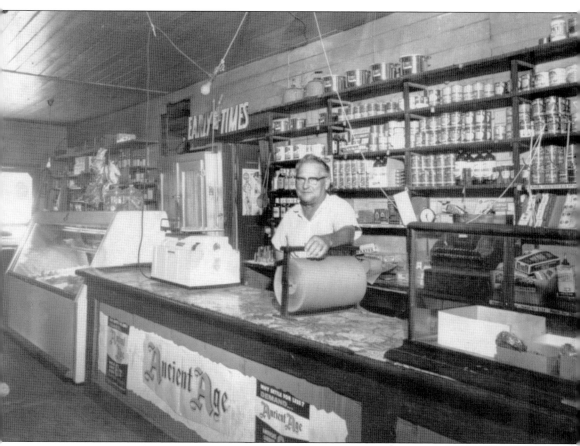

A peek inside the Arbroth Mercantile Plantation Store shows manager Wilmer Jewell behind the counter in 1955. Jewell was the store manager from the early 1940s to the mid-1970s.

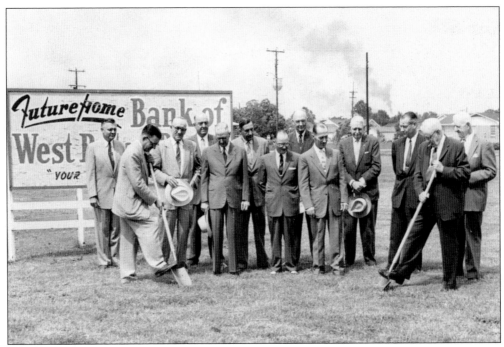

The groundbreaking ceremony for the new Bank of West Baton Rouge building took place in June 1957. The bank was granted a charter and commenced operations in 1905. It was founded by sugarcane farmers and community leaders from West Baton Rouge Parish.

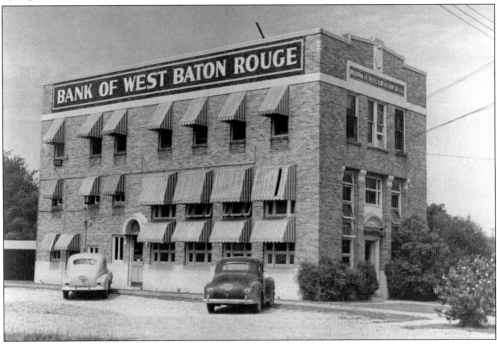

For many years, the Bank of West Baton Rouge was one of only a few banks in the parish. This is an image of the earlier bank before the reopening of the newly constructed building in 1958 on North Alexander Avenue in Port Allen.

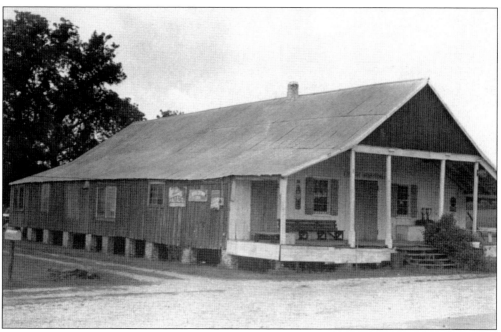

Located on River Road north of Port Allen, the Orange Grove Plantation Store opened in 1850 and remained in operation until 1960. Locals remember it warmly and considered it a great example of an authentic plantation store. As of this printing, Orange Grove Plantation Store still keeps watch over a curve in the river.

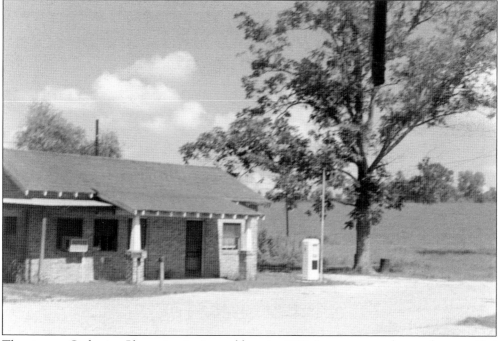

The store at Catherine Plantation is pictured here in 1968. It was a general store that provided a wide array of everyday items, but the variety of goods available was sometimes limited. These general stores began to close with the influx of big-box stores.

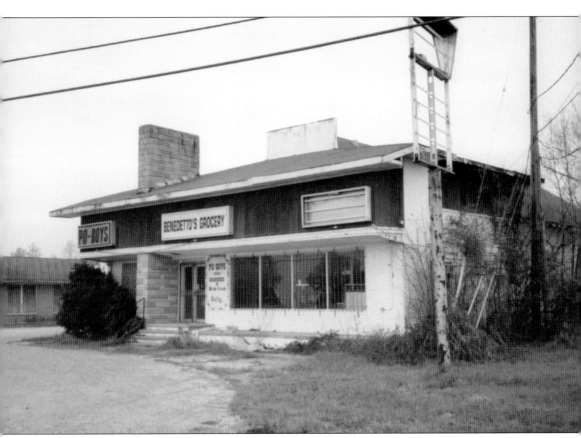

Benedetto's Grocery has been a locally owned family business in West Baton Rouge Parish since 1932. Originally in 1917, the building was the Chapel of SS Peter and Paul. Charles Benedetto purchased the old Lobdell chapel building in 1932 and opened the small grocery store and filling station just off Highway 190. Over the years, multiple locations have been opened. There are currently two stores located in Port Allen and Addis.

Four

PLANTATIONS
AND AGRICULTURE

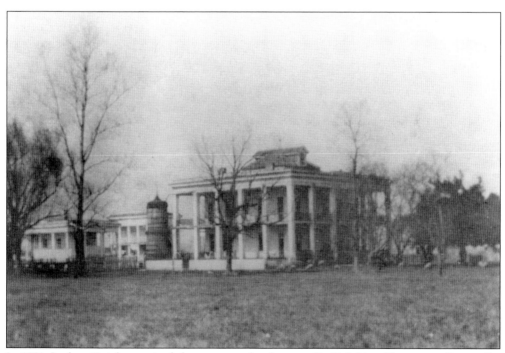

In 1831, Isadore Daigle acquired the property that became St. Delphine Plantation. Originally, it had been a Spanish land grant issued to Valery Bergeron. When Daigle married Celestine Delphine Molaison, he built the main house and named the plantation in her honor. When construction of the house was completed in 1859, it became a prominent landmark in the area. The property was sold to Auguste Levert in 1871. Later in the mid-20th century, it was sold again, this time to James H. Laws & Co.

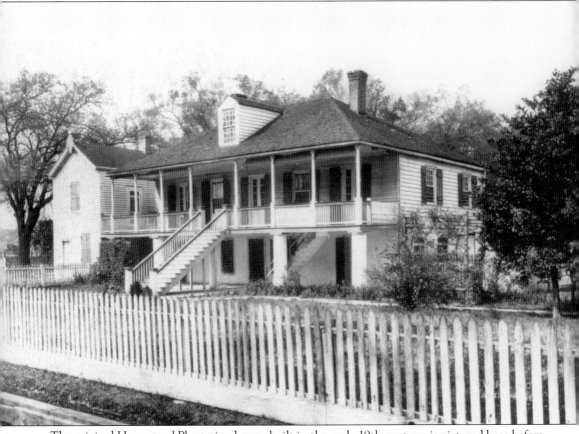

The original Homestead Plantation home, built in the early 19th century, is pictured here before the top portion of the home was moved. The home was a two-story raised Creole cottage. Early records indicate that the plantation originally produced cotton. In 1839, Alexander Barrow purchased the property and began to plant sugar.

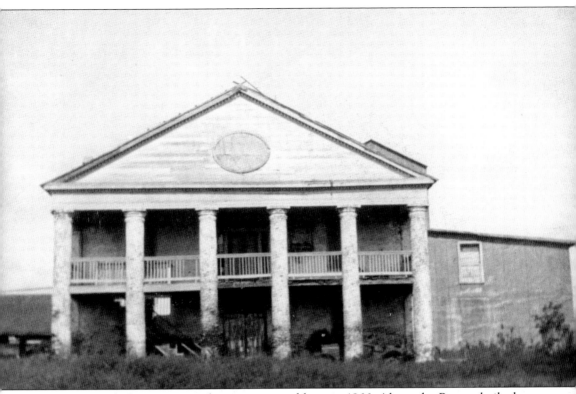

The Homestead Plantation sugarhouse is pictured here in 1966. Alexander Barrow built the sugarhouse after he bought the plantation in 1839. Barrow practiced law in St. Francisville while also running the plantation in West Baton Rouge. He would travel to Homestead during grinding season and stay in a bedroom across from the office in the front of the sugarhouse.

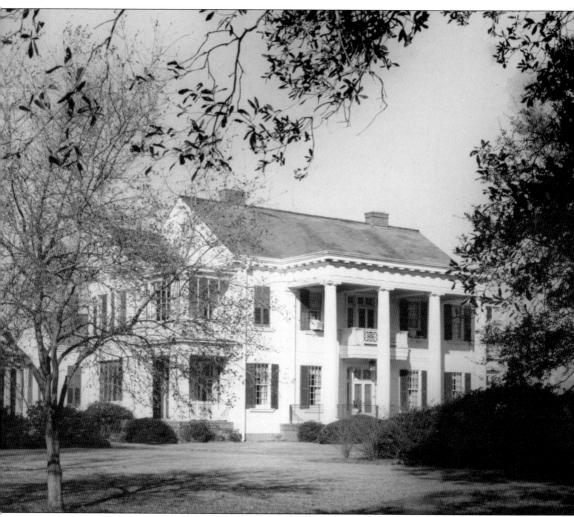

The second Homestead Plantation is a beautiful example of the Neoclassical architecture that was prominent in the early 20th century. It was designed by noted New Orleans architects Toledo & Wogan. The front porch features columns topped by a flat pediment. The second Homestead Plantation was built in 1915 by George Hill. It was a gift to his bride, Carrie Lee Taylor.

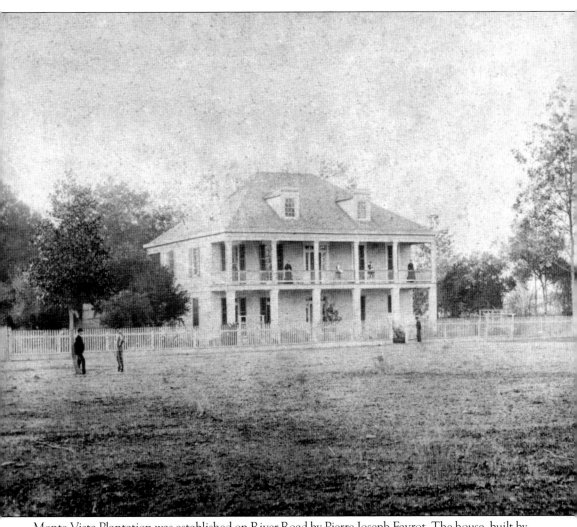

Monte Vista Plantation was established on River Road by Pierre Joseph Favrot. The house, built by his grandson in 1859, remained in the Favrot family until Horace Wilkinson purchased it in 1914.

Around 1905, sugarcane is ready to be harvested in the fields at Cinclare Plantation. The plantation's

sugar mill can be seen in the background. This photograph is erroneously labeled St. Clair.

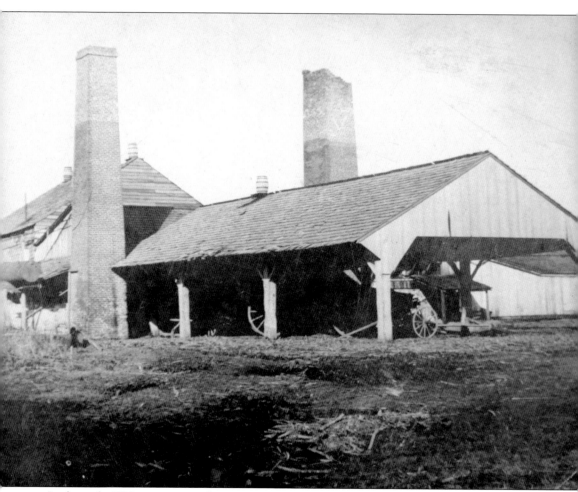

In the early 1800s, most sugar plantations in West Baton Rouge had their own sugarhouses. The sugarcane was brought here from the fields. The sugar was then extracted from the cane and converted into a marketable product.

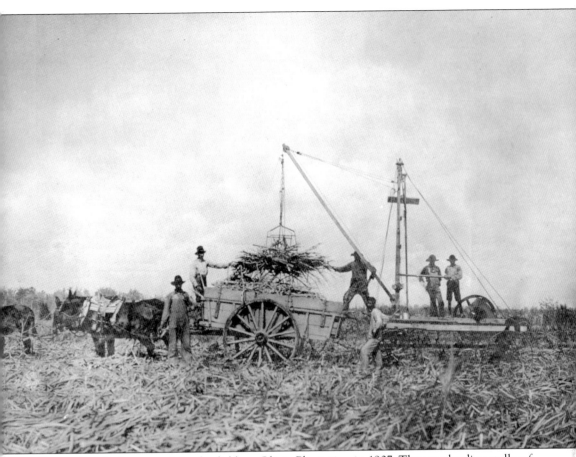

Six unidentified men work in the fields at Olivia Plantation in 1907. They are loading stalks of sugarcane into a horse-pulled wagon with a cane loader. The cane loader on this wagon was a Landry patented cane loader, invented by Delma Alcee Landry. Landry was the father of Delma Landry, the shop manager at the St. Delphine Store.

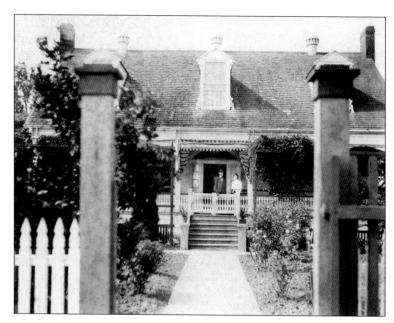

This c. 1910 image shows George Hill with his wife, Carrie Lee Taylor, standing in the gallery of the main house at Catherine Plantation. Located just north of Port Allen, the property was purchased in 1891 by Hill and named after his mother, Catherine McPhail.

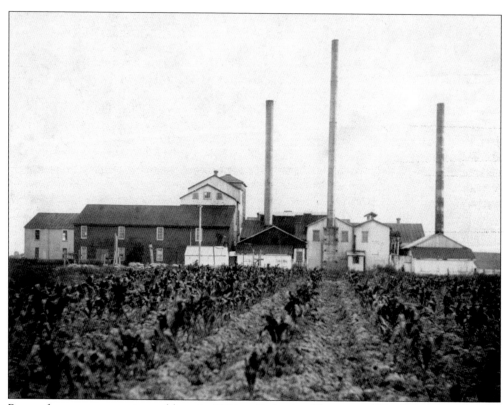

Rows of sugarcane are pictured here in 1910 at Catherine Plantation. The factory buildings of the sugar mill can be seen in the background.

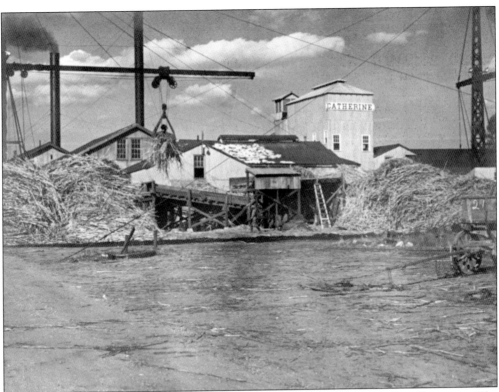

A mid-20th-century exterior view of the sugar mill complex is seen at Catherine Plantation. The plantation thrived under the supervision of George Hill, who bought the property in 1891. Sugar and molasses were produced here. For many years this mill was the last one to finish the grinding season. It would manufacture all of the sugarcane left after the larger mills closed.

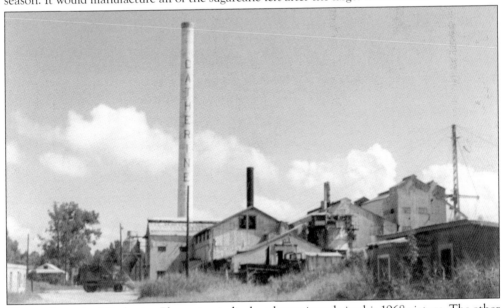

The smokestack of Catherine Plantation is displayed prominently in this 1968 picture. The other buildings in the image were all part of the sugar mill operation there.

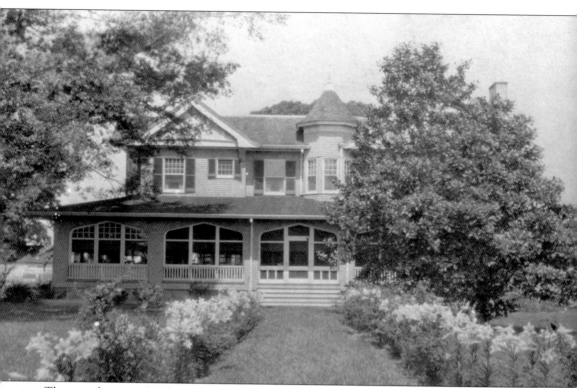

The main house at Cinclare today is the second big house on the property. The antebellum main house was relocated to nearby "Manager's Row" to make room for this shingle-style Queen Anne Victorian home. This architectural style was prevalent in the Northeast. With the James H. Laws family being from Ohio, they likely appreciated this aesthetic and selected it for their new main house, making it unique among Louisiana plantation homes.

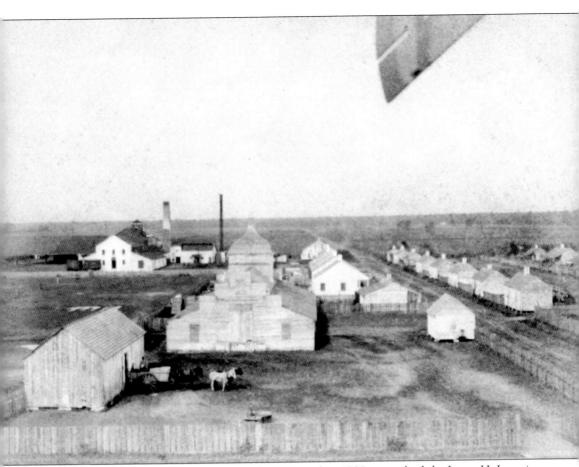

The Cinclare Plantation sugar mill complex, pictured in 1908, was rebuilt by James H. Laws in 1903. The rows of houses, off center and to the right, were ordered from Sears, Roebuck & Co.

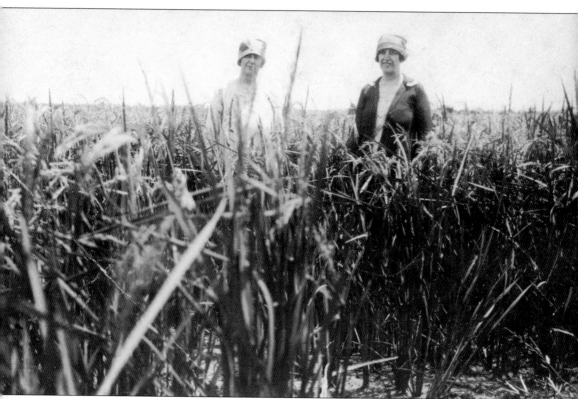

Mrs. Harry L. Laws is standing on the right with her friend Mrs. Loupe in a sugarcane field at Cinclare Plantation in the early 1930s.

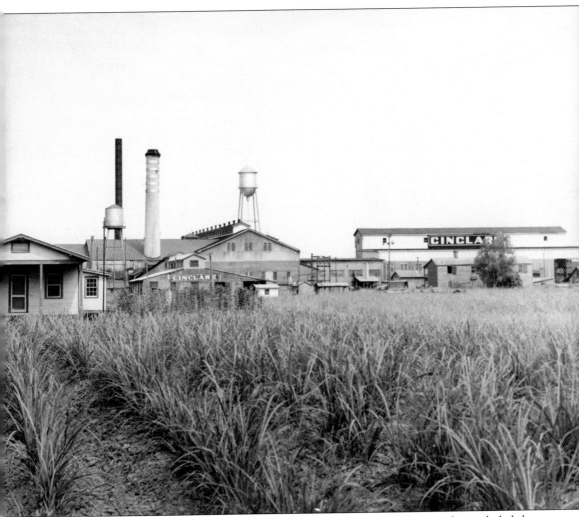

The construction of the Cinclare sugar mill was completed in 1906. The complex included the sugar mill and other manufacturing facilities and quarters for mill workers and managers. Many of the buildings in the complex were constructed facing the Mississippi River, which was the practice in the days when steamboats were a more common means of travel.

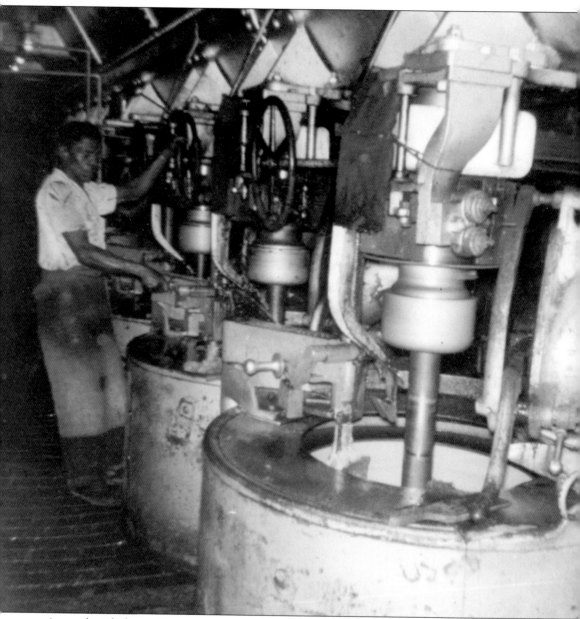

An unidentified man is operating the centrifugal at the Cinclare Central Factory. The centrifugal "spins" down the massecuite in a perforated basket-lined drum at a rate of 1,200 rpm and separates the sugar crystals from the molasses. This is done at the end of the sugar-making process, producing raw sugar for consumption, or it is further refined to white table sugar.

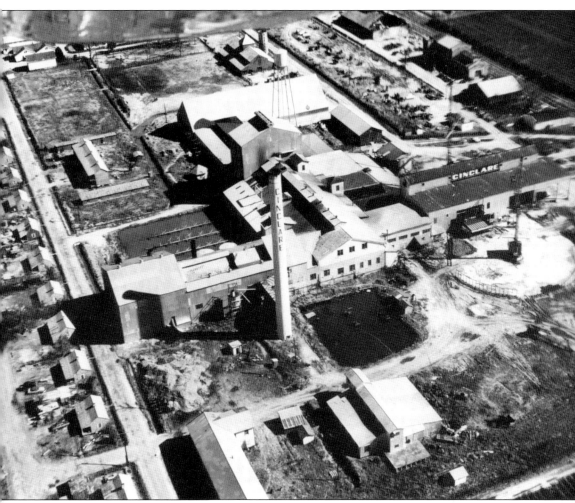

A 1968 aerial view of the Cinclare Sugar Mill is shown above. The mill and factory buildings are prominent in the center, and a row of workers' quarters can be seen to the left.

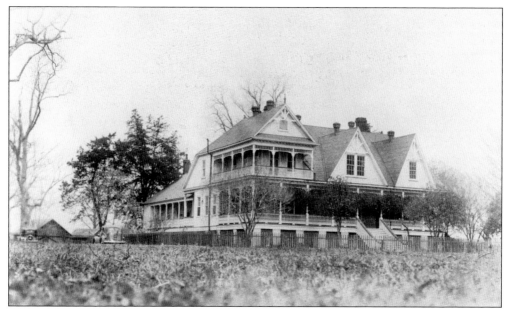

This is a c. 1940 image of the main house at Smithfield Plantation. Smithfield was a large sugar plantation in West Baton Rouge Parish. The house has been listed in the National Register of Historic Places since April 1995.

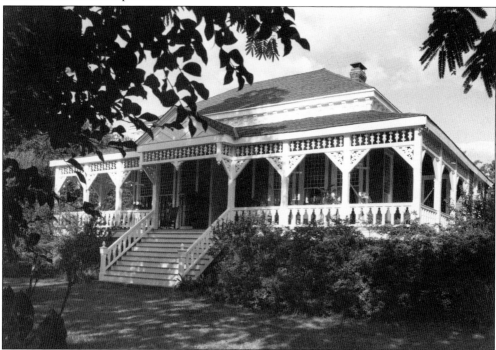

The main house at Poplar Grove, pictured here in 1976, was not initially constructed to be a home. It was built to be the Banker's Pavilion at the 1884 World's Industrial and Cotton Centennial Exposition, held in New Orleans. It was moved on a barge up the Mississippi River to Port Allen in 1886 by Joseph L. Harris. It was later purchased by Harris's cousin Horace Wilkinson, who had managed the plantation for Harris.

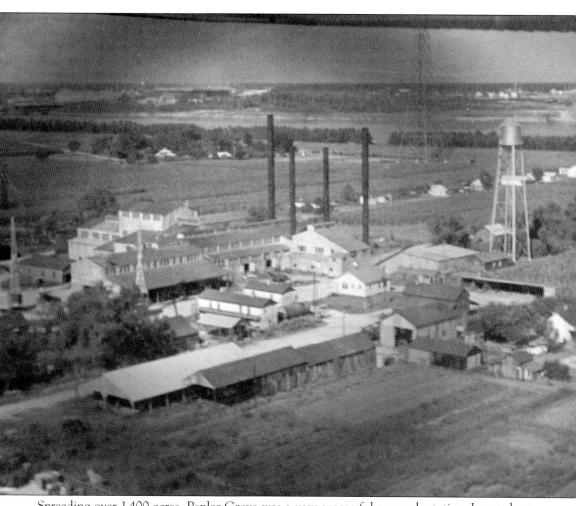

Spreading over 1,400 acres, Poplar Grove was a very successful sugar plantation. Located on the property were a sugar mill, workers' quarters, a church, a railroad, mule and hay barns, and a commissary. The mill was in operation until 1973. This image shows an aerial view over the Poplar Grove mill.

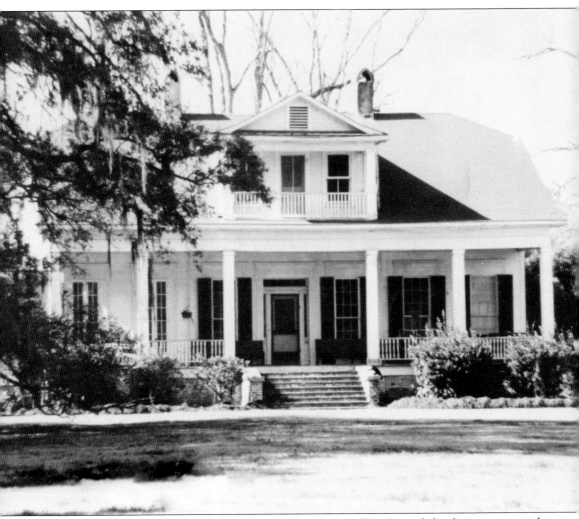

The property that makes up Sandbar Plantation was originally a Spanish land grant presented to Joseph Landry. Landry gifted the property to his only daughter, Marie Aureline, who married Dr. Thomas Philander Vaughan in 1837. The home was later inhabited by Henry Vaughan, Dr. Vaughan's son. Henry sold it to Emile Gassie in 1881. After Gassie's death, the home changed hands a couple of times before it was purchased by Charles Dameron in 1925.

This is the main house at Allendale Plantation in the mid-20th century. The original main house was burned to the ground during the Civil War. Allendale was a sugar plantation that was once owned by Henry Watkins Allen, the 17th governor of Louisiana and for whom Port Allen is named. It was purchased by Martin Kahao in 1882. The Kahaos successfully operated the sugar plantation and mill for several decades.

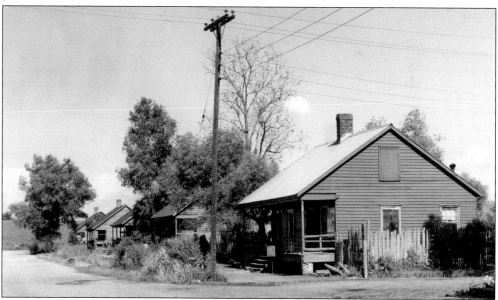

Allendale is located in the north end of the parish on the River Road. Henry Watkins Allen, a sugar planter and brigadier general in the Civil War, purchased land that would become Allendale in 1852. The cabins in the photograph were built to house the enslaved people who worked there and their descendants. They were eventually used by tenant farmers until the 1990s. This photograph shows the tenant houses in the early 1930s. Three of the structures are preserved on the grounds of the West Baton Rouge Museum.

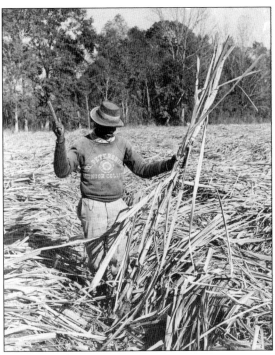

A laborer on Allendale Plantation is cutting cane with a cane knife. A cane knife has a hardwood handle, a full tang that extends the full length of the grip portion of a handle, and a deep curved blade.

The Kahao family transitioned from manual labor and mule farming, which was a labor-intensive process that required long hours behind a mule, to mechanized farming in the mid-20th century. A mechanical cane harvester is pictured here in the field at Allendale Plantation.

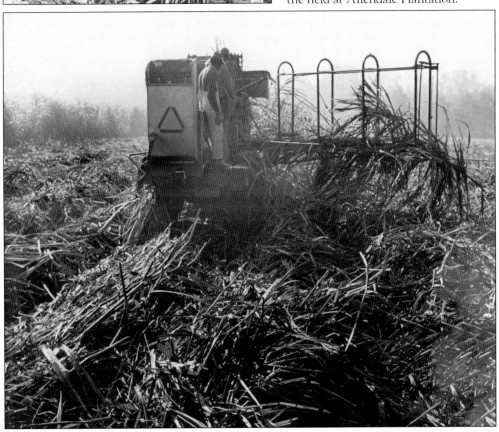

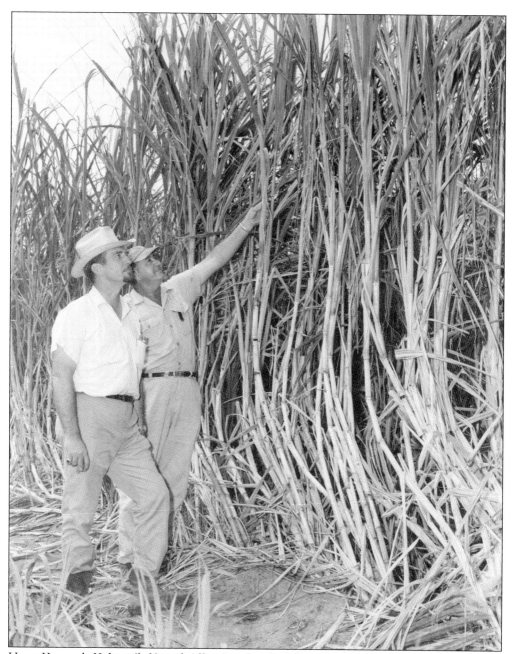

Here, Kenneth Kahao (left) and Allen Landry (right) are in a sugarcane field at Allendale Plantation. The cane stalks look to be about 10 feet high. Allendale Plantation changed hands several times, until John and Martin James Kahao purchased the plantation in 1882. The Kahao family successfully operated the sugar plantation and mill for several decades. During the second half of the 20th century, Allendale Plantation transitioned from hand labor and mule cultivation to mechanized farming.

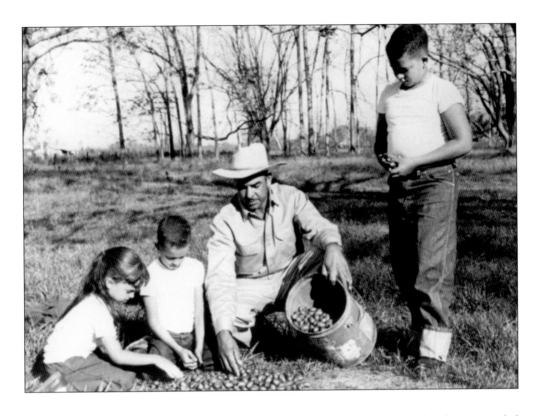

The Harleaux family is picking pecans in West Baton Rouge Parish. In 1959, the family was awarded the honor of 4-H Family of the Year. That same year, Harold Harleaux was also recognized as Louisiana Farmer of the Year.

Five

CHURCHES AND SCHOOLS

Parishioners of St. John the Baptist Catholic Church had been gathering in private homes since the late 1750s. Priests from St. Joseph Catholic Church in Baton Rouge crossed the river to administer the sacraments. The congregation built its first chapel in 1832 on land donated by Jean Baptiste Hebert. That church was overtaken by the Mississippi River. A second church was finished in 1840 but was completely destroyed in 1907. A wood-frame Gothic structure was constructed the same year and continues to serve the parish.

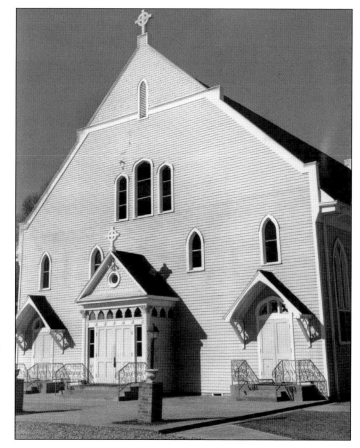

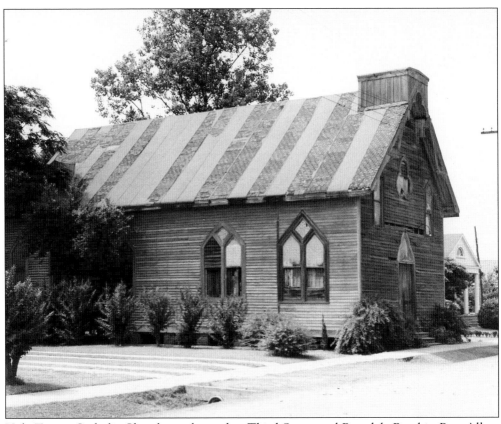

Holy Trinity Catholic Church was located at Third Street and Rosedale Road in Port Allen. Fr. Lucien Caillouet was affiliated with the church in the early 1920s and celebrated mass there regularly. The church is seen here in a mid-20th-century photograph.

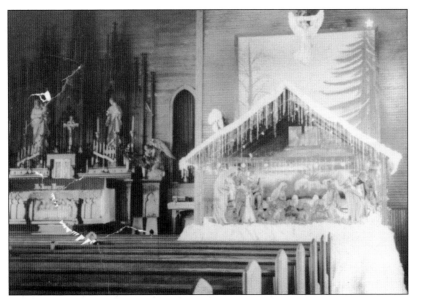

Pictured here is a 1910 image showing the interior of Holy Trinity Chapel. The altar can be seen at the left, and a nativity scene is set up on the right.

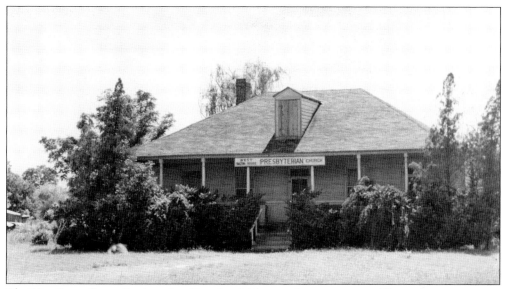

The West Baton Rouge Presbyterian Church, which started out as a group of Protestant congregants, was officially chartered in January 1939. The 51 members met at a home given to them by George Hill. That first church, which was located on River Road, is seen here in the early 1940s. It was the original Homestead Plantation home.

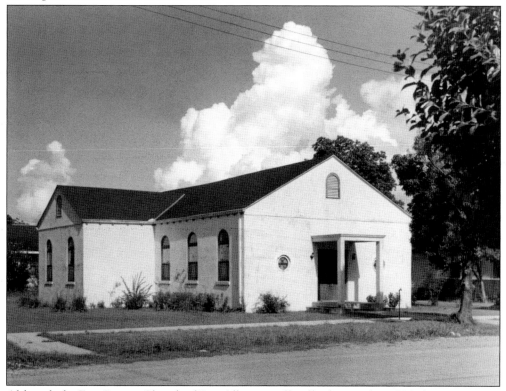

Although the First Baptist Church of Port Allen was officially chartered in 1946, the congregants had been meeting with a large community of Baptists, Methodists, and Presbyterians since 1910. Their first church building, pictured here in the early 1950s, was located on North Jefferson Avenue.

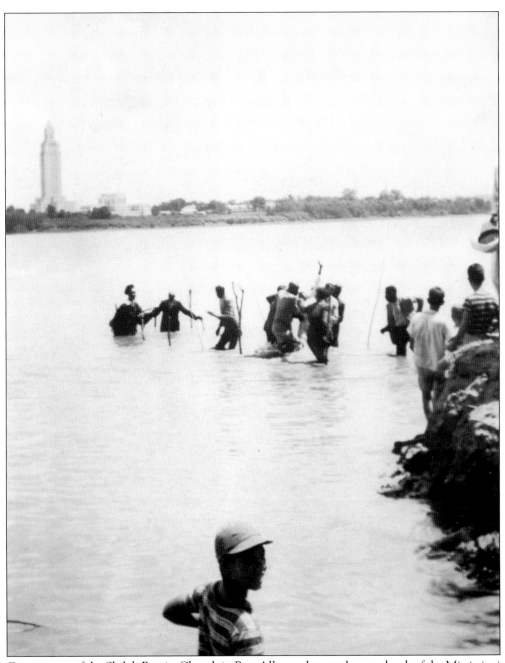

Congregants of the Shiloh Baptist Church in Port Allen gather on the west bank of the Mississippi River for a baptism in the mid-1960s. Outdoor baptisms were common in Protestant churches, especially in rural Louisiana.

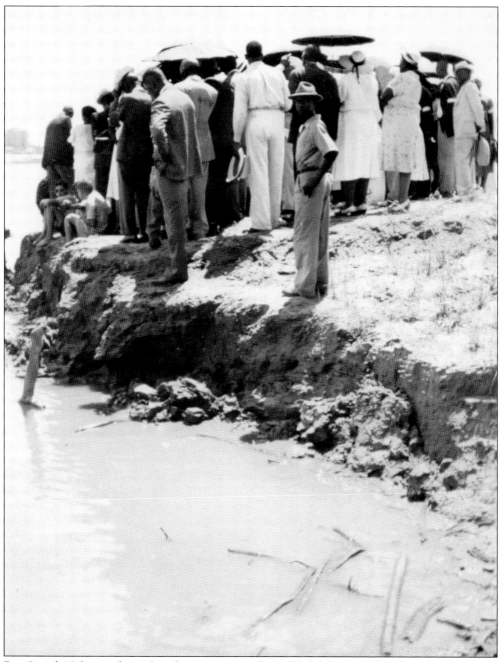

Rev. Joseph Nelson is shown here baptizing a member of Shiloh Baptist Church in the Mississippi River. Reverend Nelson served as associate pastor at Shiloh Baptist from 1964 until his death.

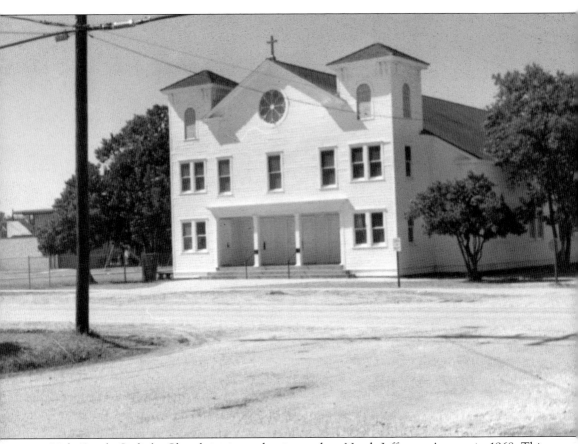

Holy Family Catholic Church is pictured as it stood on North Jefferson Avenue in 1968. This building, designed by architect William C. Miller, was erected in 1928. Unfortunately, the church suffered a fire due to an electrical short in the choir loft. The choir loft was a total loss, and there was smoke damage throughout the building. The church was demolished in 1975.

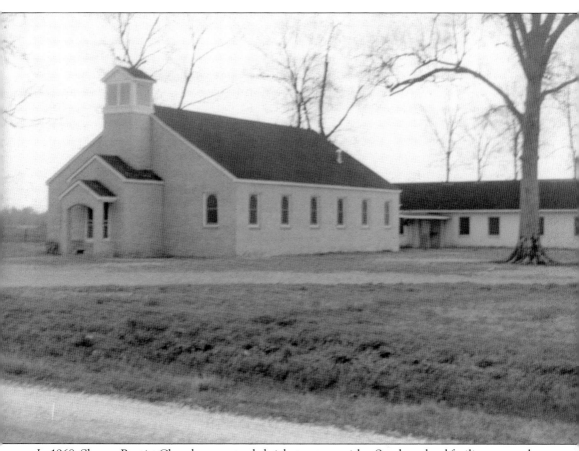

In 1968, Sharon Baptist Church was a sturdy brick structure with a Sunday school facility annexed on the back of the building. The pastor's quarters were also connected on the far end of the facility.

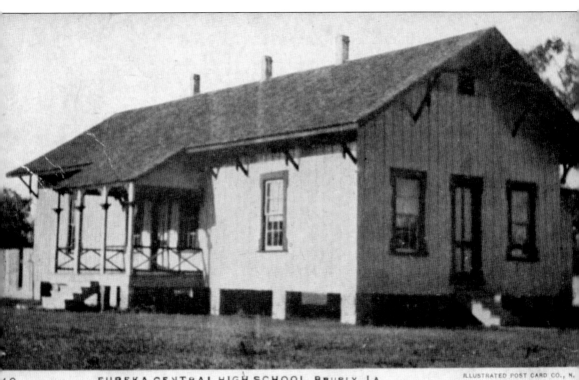

EUREKA CENTRAL HIGH SCHOOL, BRUSLY, LA.

Eureka Central High School opened in Brusly in 1888. The grades 1 through 10 were taught here until the West Baton Rouge School Board opened two new high schools for area students in 1911—Port Allen and Brusly High Schools. After it closed, the building was used as Lukeville Elementary School. This picture of Eureka Central High School was taken in 1907.

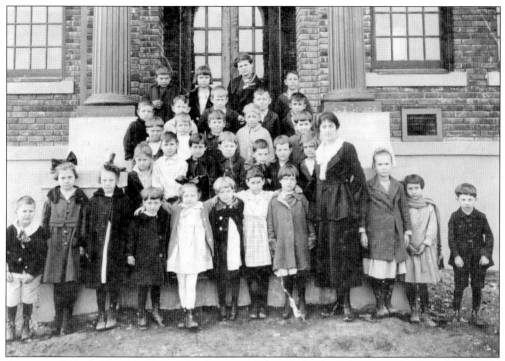

A group of 32 children made up the first, second, and third grades of Port Allen Elementary School for the 1920–1921 school year. The students are gathered on the front steps of the school, which served grades 1 through 11. Their teacher, standing on the first row, was Mable McCallum.

Port Allen Elementary School, which is located on Rosedale Road, is one of three schools in the parish that offers a Head Start and pre-kindergarten program. The school also provides instruction for kindergarten, first, and second grades.

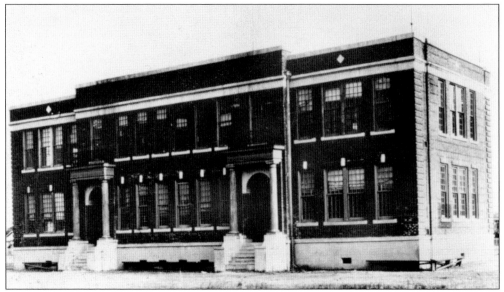

This is the first Port Allen High School building, which opened in the fall of 1922. Amelia Stevens was principal and oversaw the two-story brick building. The school started out with seven classrooms for grades 1 through 11.

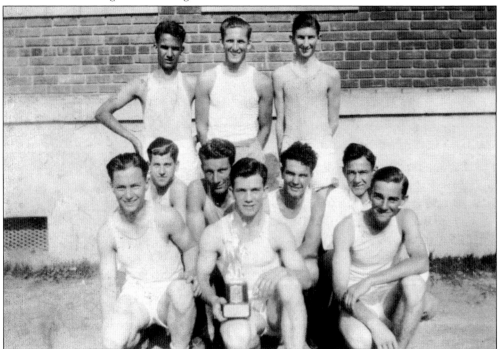

Basketball was still a new sport in the 1920s, especially for high school athletes; however, spectator sports were becoming increasingly popular during this time. The 1927 Port Allen boys' basketball team proved to be an exciting one to watch. The players pictured here are, from left to right, (first row) Milton Chance Jr., Edward Daigle, and Winfield Smith; (second row) Medric Arbonneaux, Ernest LeBlanc, Arnold Brackin, and coach J.B. Cailleteau; (third row) Chauvin Wilkinson, Horace Wilkinson III, and Leonard Roussel.

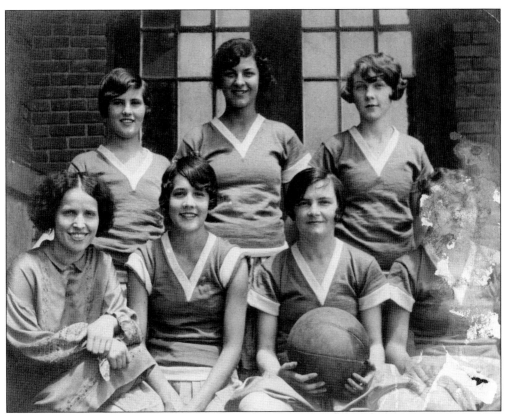

In the 1920s, the relatively new game of basketball was beginning to appear in high schools as an interscholastic sport. The girls' basketball games were very popular and very competitive. The photograph above is the 1926 Port Allen High School basketball team.

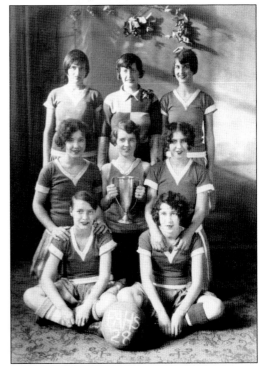

Girls' basketball at Port Allen High School flourished in the late 1920s. The 1928 team ended its season with a regional title. The team is pictured here with its title-winning trophy. The names inscribed on the back of this print are Wilma Rummel, Lillie Mae Heck, Margaret McKay, Gusta Mae Bouy, Rose Saia, and Ruth Borne.

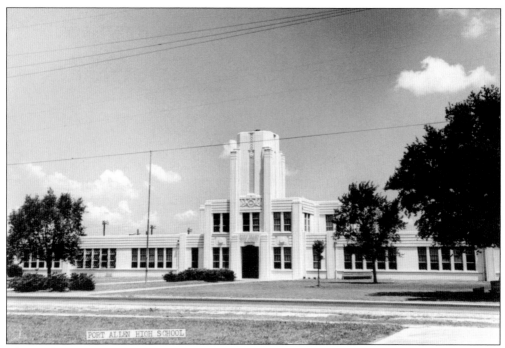

This is the second Port Allen High School building, which is located on Rosedale Road. The architecture is Art Deco with low-relief geometric shapes and patterns applied to the design. This building later became Port Allen Middle School.

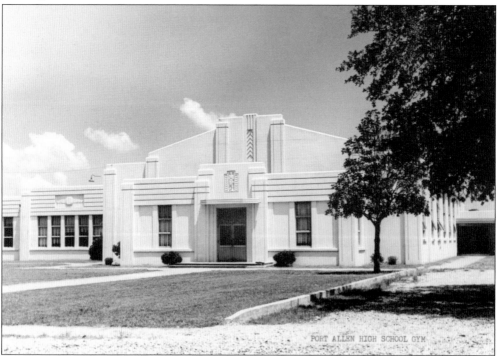

The Port Allen High School gymnasium is seen here in the same Art Deco design as the main school building. Along with the main building, the gym later became the middle school gym.

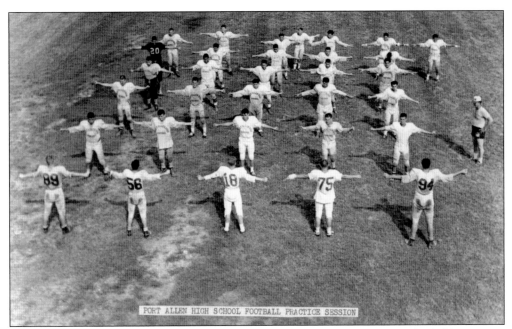

The Port Allen High School football team is pictured during practice in 1962. Athletics were an important part of Port Allen High. Student athletes learned about discipline, hard work, teamwork, and sportsmanship.

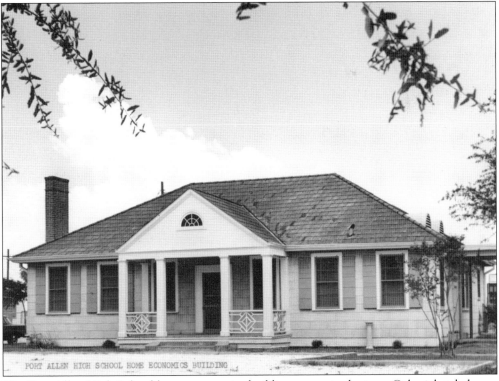

The Port Allen High School home economics building was a single-story, Colonial-style house with a hip roof. The building was used as a practice house for home economics students.

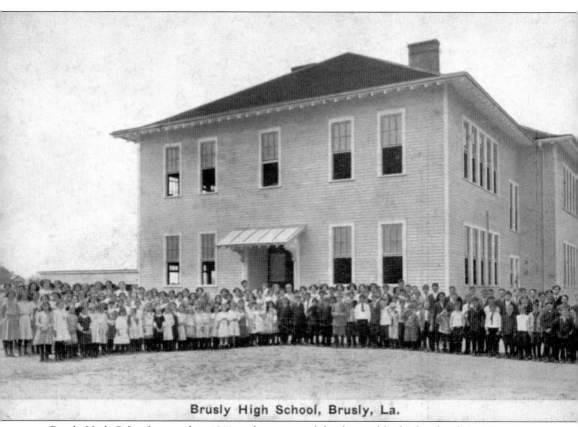

Brusly High School, Brusly, La.

Brusly High School opened in 1911 and was one of the first public high schools in West Baton Rouge Parish. It was a two-story wooden building and served grades 1 through 11. The 12th grade was added in 1949. The flat-roofed structure seen behind the students is a shelter for the horses and buggies, the teachers' mode of transportation to school. This building was demolished in 1950.

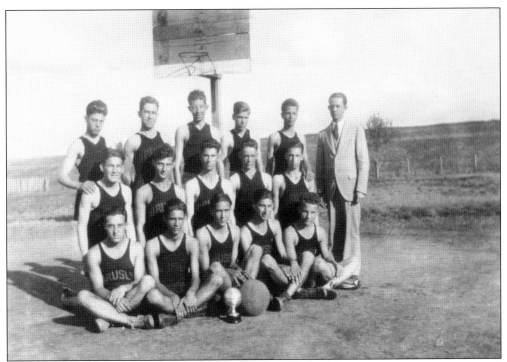

In the 1920s, basketball was becoming an increasingly popular sport throughout the parish. The 1929–1930 Brusly High School boys' basketball team is pictured here on the school's court.

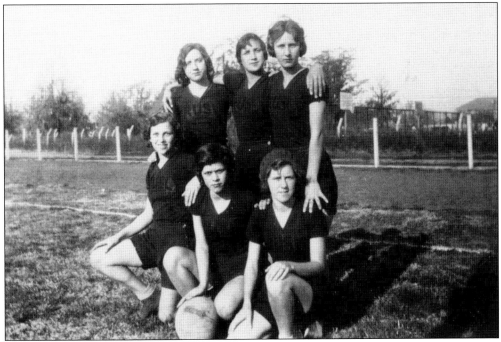

Girls' athletics, especially basketball, was becoming more popular across the nation. The Brusly High School girls' basketball team, wearing the team uniform with "Brusly" emblazoned across the chest, is shown here in 1929–1930.

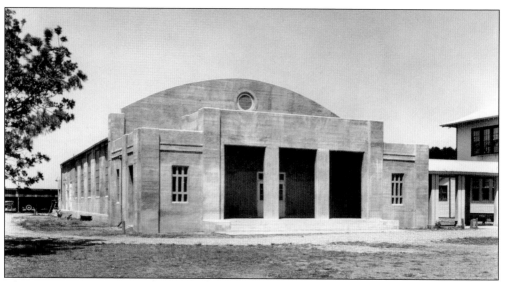

The Brusly High School gymnasium was built as part of a Works Progress Administration (WPA) project. Construction started in early January 1937 and took exactly six months to complete. The building's architectural style is typical of many of the WPA projects, and it is a great example of the postwar Modernism that was taking place in construction around the nation. In the background one can see the garage where teachers parked their cars. (Courtesy of the Town of Brusly Historical Collection.)

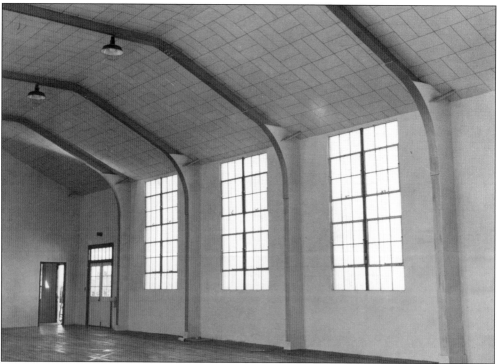

The inside of the Brusly High School gymnasium is pictured here in the summer of 1937. The gym was also designated as a community gathering place and used for hurricane evacuations. (Courtesy of the Town of Brusly Historical Collection.)

The second Brusly High School building was opened in 1948. Simple forms and hard lines that dominated most architecture of the 1940s influenced the design of the new school building. (Courtesy of the Town of Brusly Historical Collection.)

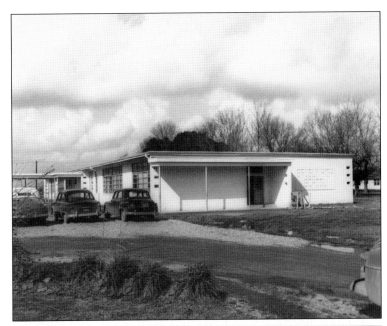

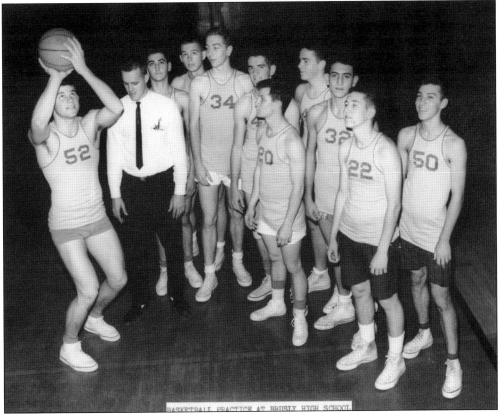

The Brusly High School boys' basketball team crowds around its coach, Buddy Charleville, at practice in the late 1950s. Coach Charleville taught at Brusly High School and later became principal. He then went on to serve as West Baton Rouge Parish school board superintendent.

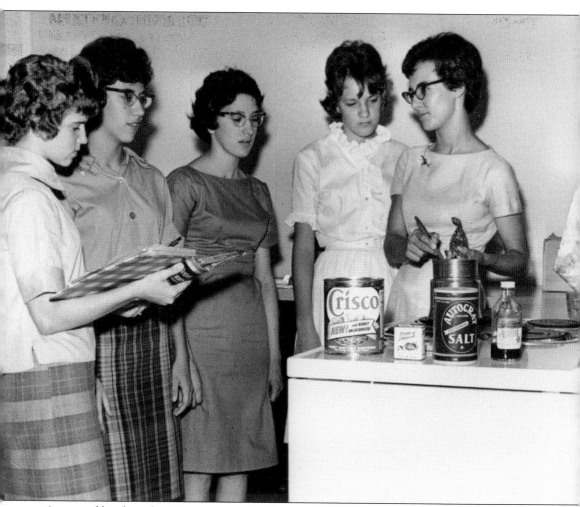

A group of female students is participating in a home economics class at Brusly High School. Students in home economics classes learned about cooking, nutrition, housekeeping, and personal finance.

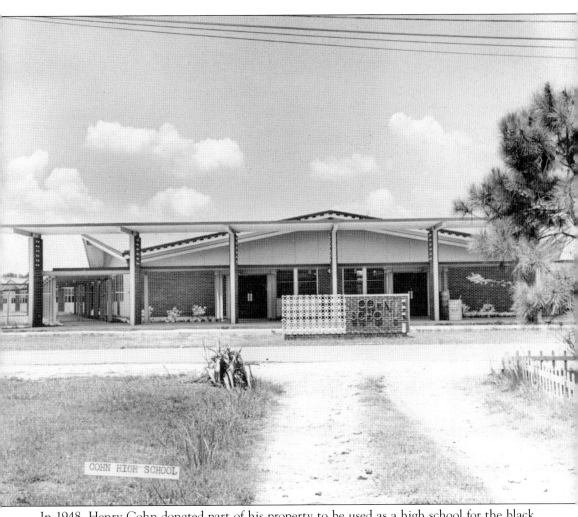

In 1948, Henry Cohn donated part of his property to be used as a high school for the black students of West Baton Rouge. Cohn Junior and Senior High School opened on August 31, 1949, with Oliver Baham as principal. Those teaching with Principal Baham were James Gray in mathematics, Shirley Baham in home economics, Johnny Hayes in science, Nora Hartson in English, and Julia Coffey in social science. This building sustained damage during Hurricane Gustave and was demolished in 2014.

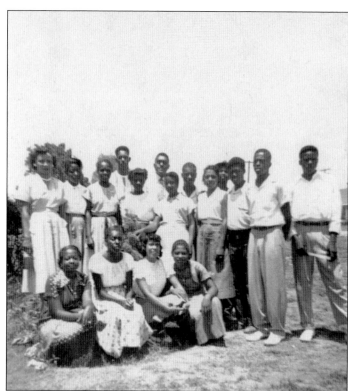

A group of unidentified male and female students are pictured at Cohn Junior and Senior High School. In the fall of 1949, a total of 123 students enrolled at the school. By 1951, the school had expanded from one to three buildings to accommodate its growing student body.

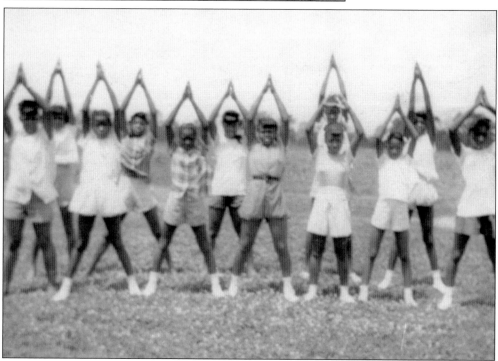

An eighth grade gym class is pictured at Cohn Junior and Senior High School. To accommodate the growing class sizes, Cohn eliminated the junior high shortly after it opened in 1949.

Cohn students pose in front of a car in the 1950s. For many students, Cohn High was a safe place to gather without fear of harassment. Cohn High also served as a meeting place for black residents who were barred from many other public buildings during segregation laws and practices.

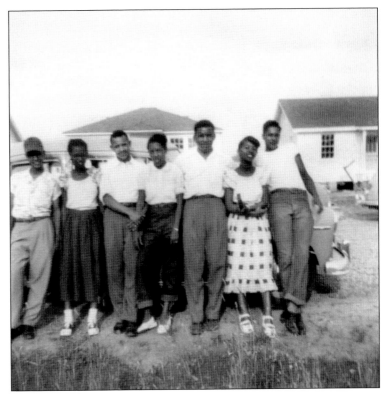

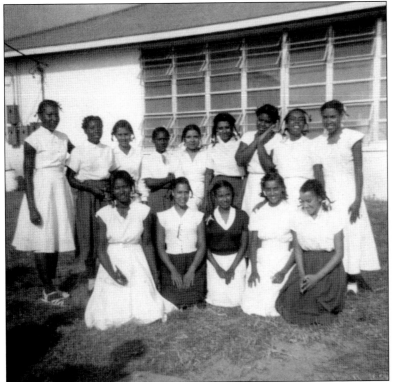

A group of girls gathers outside Cohn High's classrooms. Before Cohn opened its doors, only 64 percent of school-age black children were able to attend public school in West Baton Rouge Parish. By 1957, that percentage jumped to 99 percent.

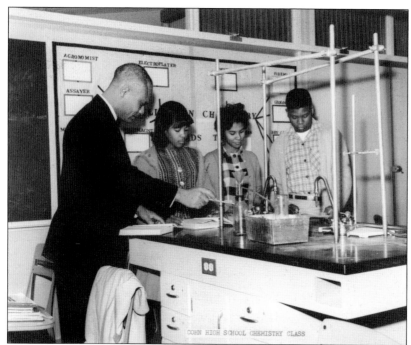

Prof. John Hayes stands at left leading a chemistry lesson with, from left to right, students Norma Gus, Marilyn Miller, and Ernest Noel in 1962.

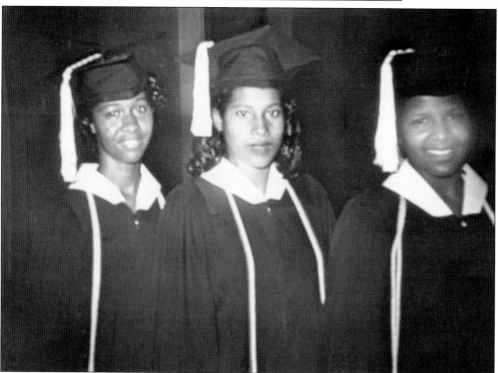

Arthell Collins (later Brown), Wilhelmenia Williams (later DeCuir), and JoAnn Harris are shown at their 1955 graduation from Cohn High School. They were part of the sixth graduating class from the school. Wilhelmenia Williams DeCuir later served as a librarian at Cohn High and as a West Baton Rouge Historical Association board member.

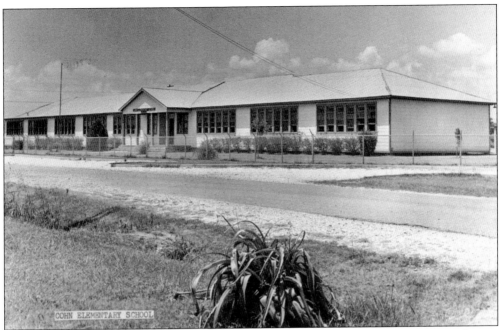

Cohn Elementary School was established on property donated by Henry Cohn Jr. It was adjacent to the high school.

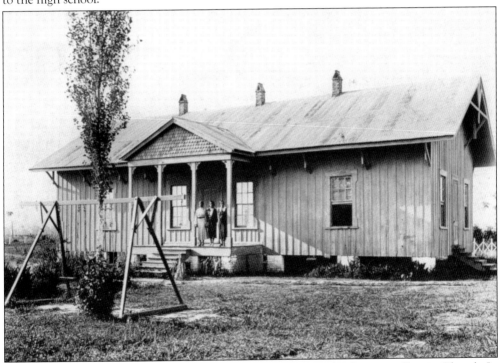

Rev. Luke Billups organized Lukeville School in 1887 at Antioch Missionary Baptist Church. In later years, the Eureka Central High School building was moved to Lukeville, and that building was used for classes. Since its founding, students in the lower and upper elementary grades were taught here. (Courtesy of the Town of Brusly Historical Collection.)

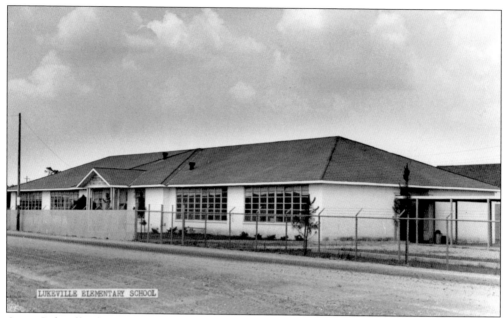

A new Lukeville Elementary School building was constructed and opened in 1950 to serve the black students of Addis, Brusly, and Lukeville. First through eighth grades were taught there for almost 20 years. In 1969, Lukeville Elementary was integrated with Brusly Elementary. Lukeville became the lower elementary school for the area, serving grades one through four. A kindergarten was added in 1976.

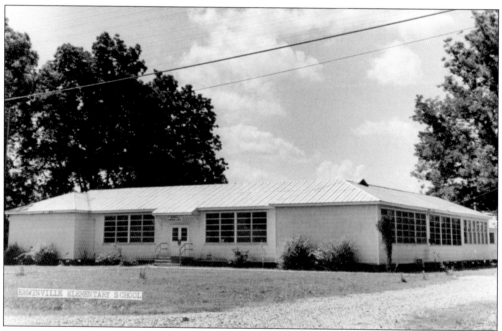

In 1950, the newly built Erwinville Elementary School opened. The building contained only three classrooms and a kitchen that first year. And the faculty consisted of two teachers and a principal for 125 students. By 1958, two more classrooms were added, along with a lunchroom, principal's office, and a teachers' lounge.

Six

COMMUNITY

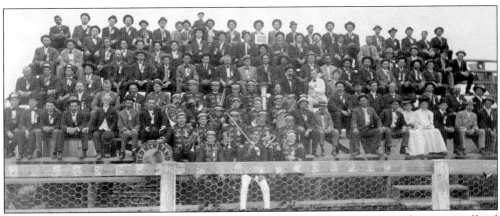

The Red Men Band, a community band from Brusly, is pictured around 1910. The group's official title was the Improved Order of Red Men, and it was a national fraternal organization. The band was primarily a brass and woodwind band. It was composed of volunteer musicians from the area. The group rehearsed regularly and performed at holiday and patriotic events.

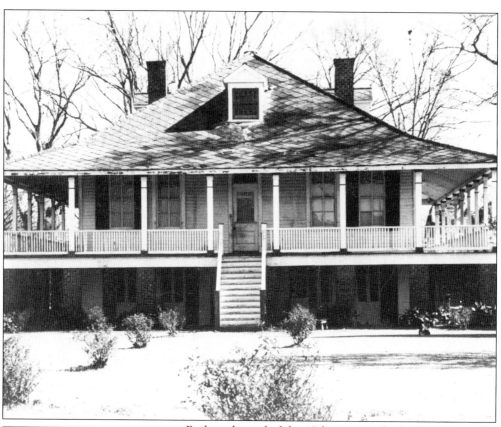

Built at the end of the 19th century, the Lockmaster's House in Brusly is a raised West Indian–style home encircled with porches and formerly located at the Plaquemine Locks. Porches were a way to protect buildings from the elements and provide cooler shaded spaces before the advent of central air.

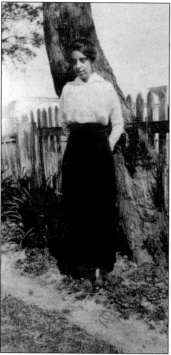

Isabelle Dubroca lived and taught in West Baton Rouge Parish in the early 1900s. She was the daughter of Sallie and Adolph Dubroca. She was an accomplished student and studied in Paris after finishing her secondary education. She wrote a biography about a distinguished New Orleans educator, Eleanor McMains, titled *Good Neighbor, Eleanor McMains of Kingsley House.*

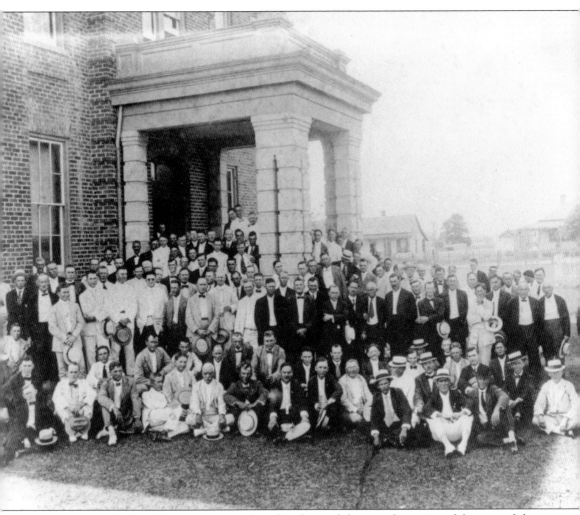

A large crowd of local businessmen gathered in front of the courthouse in celebration of the first oil pipeline placed from the west through West Baton Rouge Parish to Baton Rouge by the Standard Oil Refinery in 1910.

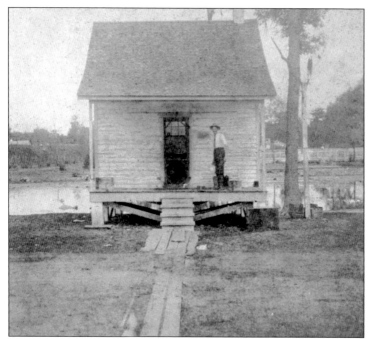

Dr. Paul B. Landry Sr. is pictured in front of his medical office in Morley around 1912. Dr. Landry graduated from Tulane University with a doctorate in medicine in 1904. He started out as a medical inspector for the Louisiana State Board of Health. He established his medical practice first in White Castle, then in Plaquemine, and later in Morley. In 1917, he finally settled in Port Allen where he practiced and also worked as the parish coroner for many years.

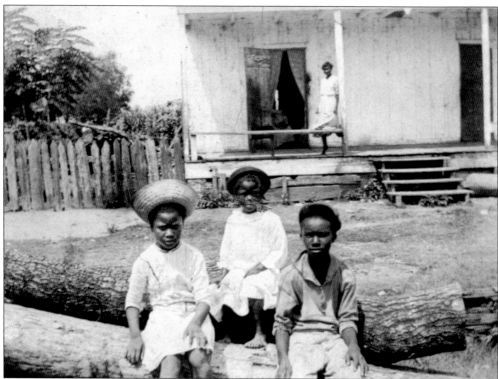

Three children sit on a log in front of a cabin on Allendale Plantation in 1915. One woman can be seen standing on the porch leaning on the railing. Another woman is seen sitting on a chair inside the doorway. The two-room cabin was later moved from Allendale to the grounds of the West Baton Rouge Museum.

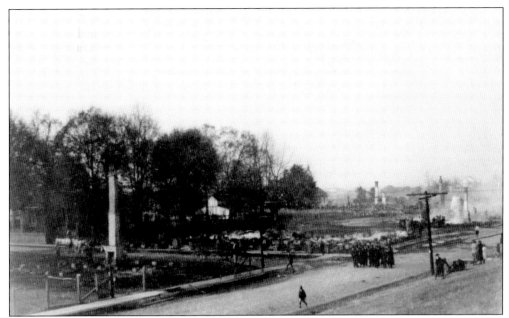

The aftermath of the devastating Port Allen fire of 1918, which destroyed several businesses on the north side of town, can be seen here. Cohn's Store and Dr. Beiner's Drug Store were among the carnage of the day. This photograph was taken from the levee showing what was left of the area.

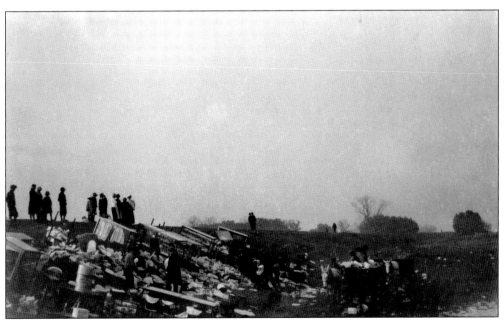

Some furniture and other items were saved from the ruins of the Port Allen fire of 1918. What could be salvaged was piled and collected on the levee. A portion of the area is still smoldering in the background of this photograph.

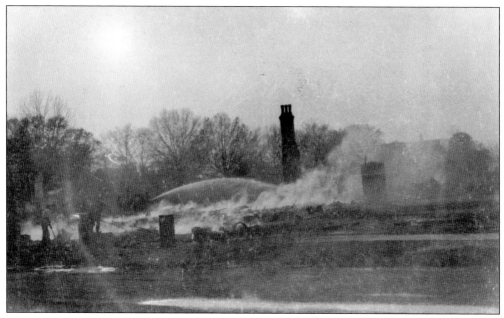

At the time, there was no local fire department to safeguard Port Allen or West Baton Rouge Parish. Firemen had to be ferried over the Mississippi River to extinguish the flames that had advanced eight blocks before it was under control.

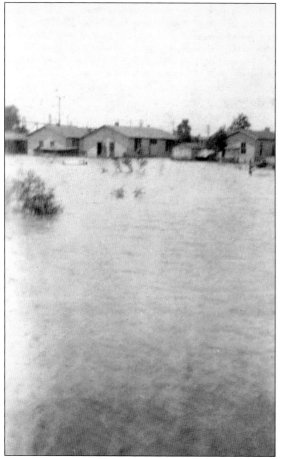

The Great Mississippi Flood of 1927 was the most devastating flood in written history in the lower Mississippi Valley. Because of the unprecedented amount of water in the Mississippi River, from thawing snow in the north and continuous rain in the south, the levee in West Baton Rouge collapsed. This is a photograph of the flood waters surrounding homes in Port Allen.

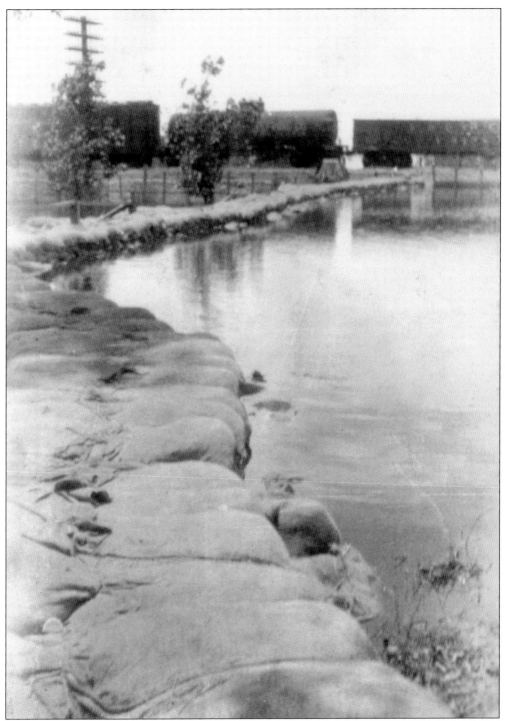

The high waters that became the Great Mississippi Flood of 1927 put a great strain on the levee system, which was unregulated and already weakened in many areas. There were 77 levee crevasses in all. Twenty-six thousand square miles of land were flooded. It was the country's most devastating natural disaster up until that time.

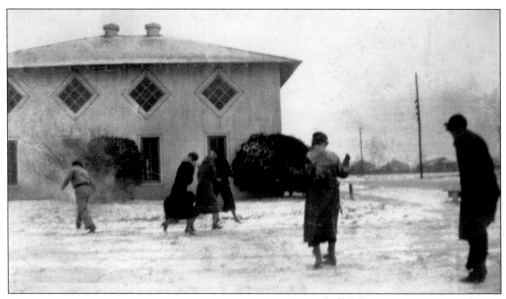

A snowball fight among townspeople in January 1934 took place in front of what was then Port Allen's town hall. Louisiana has a subtropical climate, making snow in the southern part of the state a rare event. So when snow does fall, it creates a delightful experience.

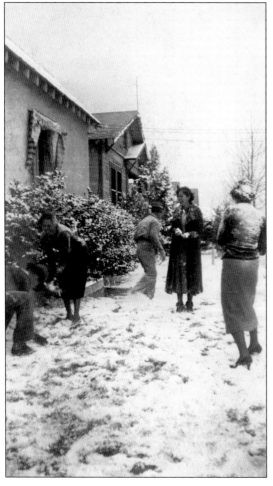

In January 1934, Port Allen residents are taking part in the revelry of a snow day. Because of the infrequency of freezing temperatures in this part of the state, locals relish the event.

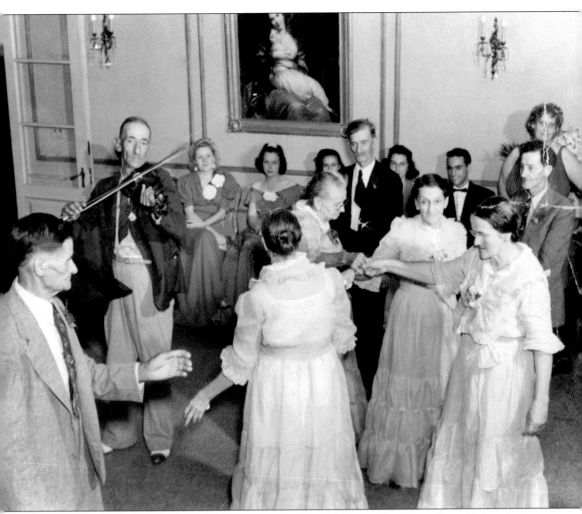

The Les Lanciers dance group is performing at the French House at Louisiana State University in February 1941. Louise Oliver organized the event to rekindle the enthusiasm for the old Assembles Françaiseé dances that were once held in the southern Louisiana communities. The dancers pictured here are, from left to right, Amy Thibodeaux Hunt, Ozemee LaBauve, Kate Landry LeJeune, Edgar Templet, Murat LaBauve, Ella LaBauve Tullier, and Octave LaBauve. Wallace Doiron Sr. is playing the violin.

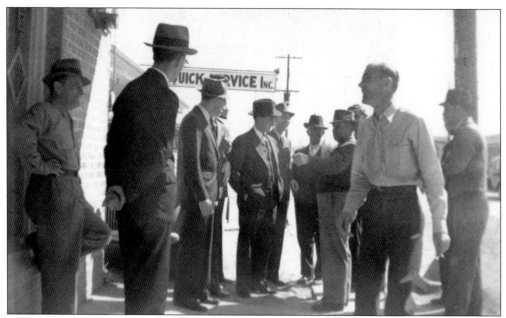

After a long day of work, local businessmen visit in front of a local store on Court Street in Port Allen. These sharp-dressed men of the 1950s wore suits that were the prevalent design of the time. The suits had a fuller cut and were single-breasted with long, wide lapels.

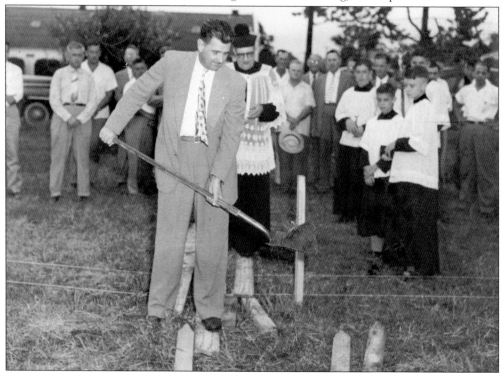

René Mouton is seen here with a shovel at the groundbreaking ceremony for the Knights of Columbus Hall in August 1949. Fr. Allard M. Domsdorf, then the pastor at Holy Family Church, is standing behind Mouton. The hall is located on North Jefferson Avenue in Port Allen.

Kenneth Kahao is pictured with the 19 contestants of the Queen Sugar Pageant in 1956. The group is at a tea at the Cinclare Plantation home.

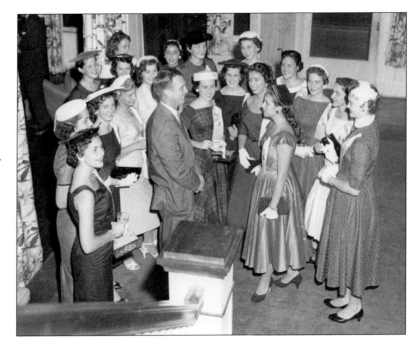

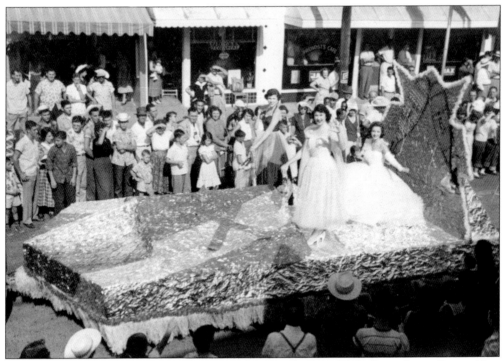

The Queen Sugar Pageant queen, Cleeta "Duckie" Daigle (later O'Neal), is riding a float in New Iberia representing West Baton Rouge Parish. On either side of her are maids Lois Landess (left) and Ione Vavasseur (right).

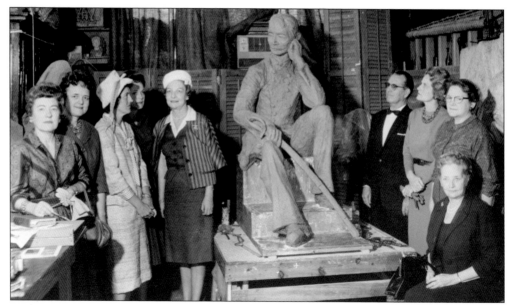

In the early 1960s, a committee was formed to commission and erect a statue of Henry Watkins Allen, the namesake of Port Allen. Angela Gregory, a well-known Louisiana sculptor, was contracted to design the sculpture. This is the final clay model of the Henry Watkins Allen monument, and the committee is in Gregory's studio assessing the work in progress. The committee members are, from left to right, Libby Hill, Marguerite Genre, Evelyn Terrill, Mary Dameron, Virginia Phillips, Teddy Landry, Palma Munson, Angela Gregory, and Ethel "Puffy" Dameron.

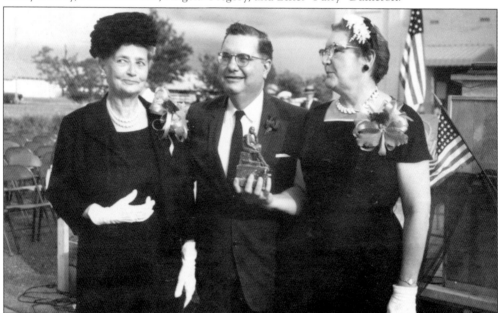

Puffy Dameron (left), head of the Henry Watkins Allen Statue Committee, is pictured with Harnett Kane (center) and Angela Gregory (right) at the statue's dedication ceremony. Kane was the event's featured speaker. Gregory is the sculptor of the statue, and here, she holds a maquette of her sculpture. Four of the maquettes that Gregory created are part of the West Baton Rouge Historical Association's permanent collection.

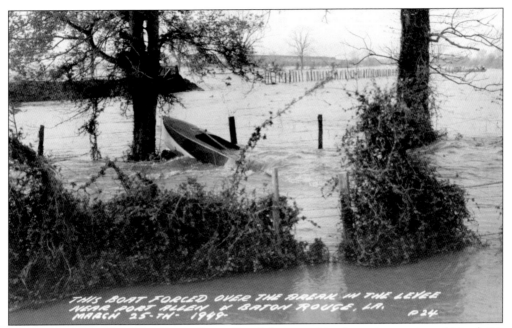

The last levee break in West Baton Rouge Parish happened in the early morning of March 24, 1949, when the Mississippi River broke through the levee just north of the Port Allen. Within three hours, the water had moved three miles inland from the river.

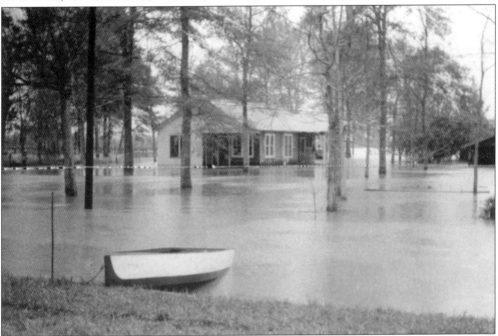

The flood of 1949 came as a complete surprise to river forecaster Stephen Lichtblau of the US Weather Bureau in New Orleans. The Mississippi River was a foot below flood stage in Port Allen just the day before; it was not considered dangerous. Apparently, the water was just high enough to come through the break. A flooded house is seen here among the damage in West Baton Rouge Parish.

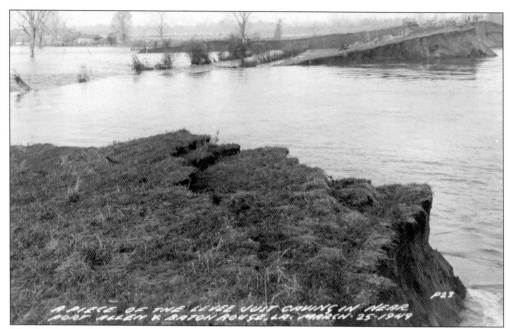

The break in the levee just north of Port Allen, which resulted in the flood of 1949, is shown above. Officials reported water flowing through a gap that was about 200 feet wide with the levee crumbling on either side.

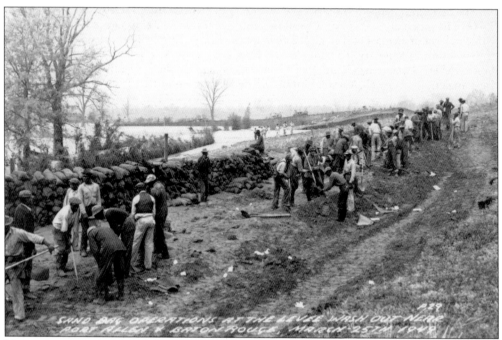

Here, laborers work to block the flow of water caused by a breach in the levee system. The relief effort provided by the sandbag operations was successful in holding the river water back until the levee could be repaired.

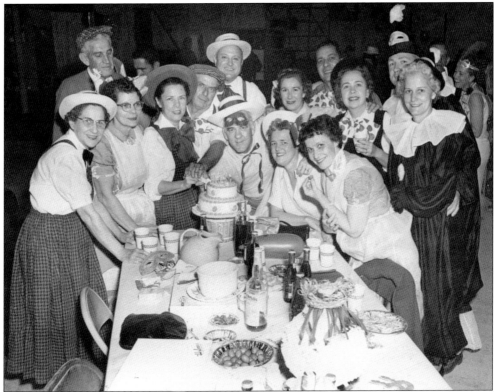

The Nepenthian Dance Club was a social dance club in Port Allen in the 1950s, 1960s, and 1970s. The group derived its name from Nepenthe, a fictional drug in Greek literature used to induce a lapse of memory and eliminate grief or trouble from a person's conscience. The members gathered here in February 1958 are Newton Plaissance, Pearl Miller, Jenny Daigre, J.E. Daigre, Lester Hebert, Marguerite Genre, Viola Templet, Richard Genre, Janice Hebert, Allie Langlois, Iris Langlois, Guy Otwell, Marion Otwell, A.J. Webb, and Bonnie Fuglar.

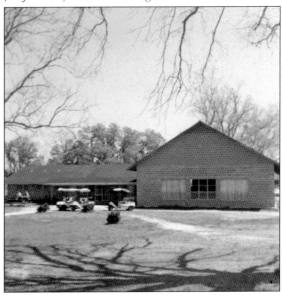

The West Side Country Club is pictured in April 1968. The club, established in Brusly in 1963, had an 18-hole golf course and operated until the spring of 2020.

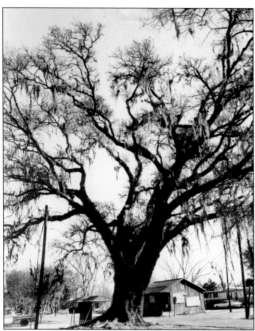

The Back Brusly Oak, located in the west side of Brusly off Highway 1, is one of West Baton Rouge's most famous landmarks. In October 1960, it was the first tree to be registered with the Louisiana Live Oak Society. It is 25 feet in circumference and believed to be close to 400 years old.

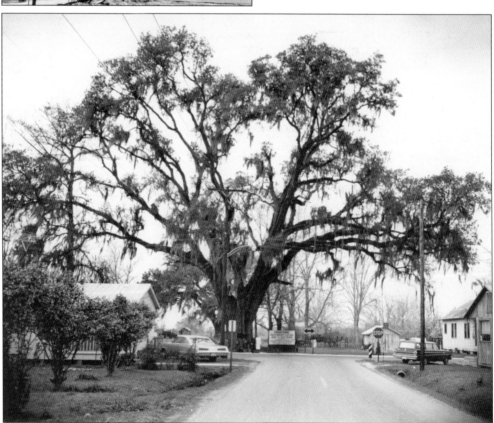

Ethel Claiborne "Puffy" Dameron and Brusly Mayor Howard Labauve can be seen in the distance in front of the Back Brusly Oak tree in Brusly.

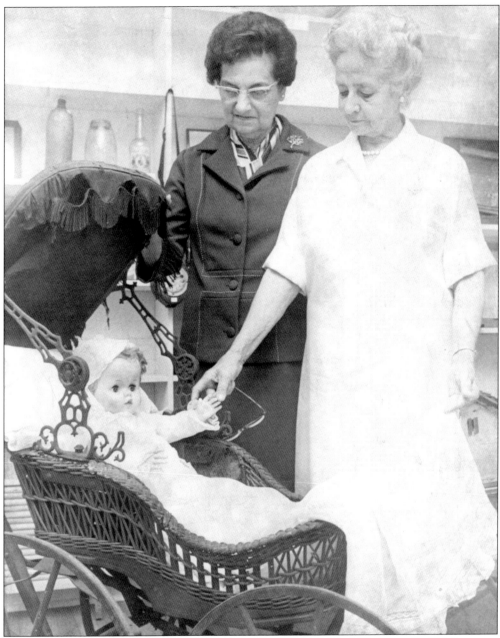

West Baton Rouge Museum Board members Elsie Lefebvre and Ethel Claiborne "Puffy" Dameron look over an old baby carriage donated by Paul Perkins. The carriage is one the museum's earliest artifacts in the West Baton Rouge Historical Association permanent collection.

Discover Thousands of Local History Books Featuring Millions of Vintage Images

Arcadia Publishing, the leading local history publisher in the United States, is committed to making history accessible and meaningful through publishing books that celebrate and preserve the heritage of America's people and places.

Find more books like this at
www.arcadiapublishing.com

Search for your hometown history, your old stomping grounds, and even your favorite sports team.

Consistent with our mission to preserve history on a local level, this book was printed in South Carolina on American-made paper and manufactured entirely in the United States. Products carrying the accredited Forest Stewardship Council (FSC) label are printed on 100 percent FSC-certified paper.

MADE IN THE USA